THE YOUNG CARTOONIST

THE YOUNG CARTOONIST

The ABC's of Cartooning

By
Syd Hoff

A RAINBOW BOOK

STRAVON EDUCATIONAL PRESS

New York, N.Y.
ISBN 0-87396-094-7

ISBN 0-87396-094-7

Acknowledgements

Previously copyrighted material appearing in this book is reprinted by permission. Credits are printed under or alongside each picture except for the bordered cartoons appearing on pages 7, 9, 11, 12, 13, 14, 16, 17, 19, 21, 22, 23, 24, 26, 28, 33, 34, 36, 37, 38, 42, 43, 44, 45, 50, 51, 52, 53, 54, 55, 59, 60, 61, 63, 71, 75, 80, 81, 82, 84, 85, 86, 87, 88, 90, 91, 93, 94, 95, 96, 97, 98, 99, 103, 104, 105, 106, 108, 111, 112, 114, 115, 116, 117, 119, 122, 124, 125, 127, 130, 131, 133, 134, 135, 140, 141, 142, 143, 144, 145, 147, 151, 152, 153, 154, 155, 157, 160, 163, 164, and 165. These cartoons are selections from the author's daily newspaper cartoon panel "Laugh It Off" which is distributed world-wide by King Features Syndicate.

Library of Congress Cataloging in Publication Data

Hoff, Syd, 1912-
 The young cartoonist.

 Summary: A well-known cartoonist explains how to draw cartoons and comic strips, how to make up jokes, and where to have one's work displayed.
 1. Cartooning—Juvenile literature.
[1. Cartooning] I. Title.
NC1320.H58 1983 741.5 82-5980
ISBN 0-87396-094-7 AACR2

Composition by Delmas, Ann Arbor, Michigan
Printed in the Unites States of America

CONTENTS

Dedication

For the girl who married a young cartoonist

A MESSAGE TO THE YOUNG CARTOONIST

CARTOONING is great fun. It's fun for the people who look at cartoons but it's even more fun for the people who draw them. Nothing excites a cartoonist more than being faced with a blank sheet of paper. His, or her, imagination starts running wild. And when he, or she, takes a pen, pencil, brush, or crayon in hand get ready to laugh. Always

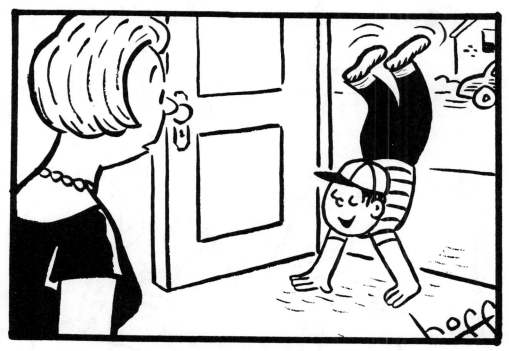

"Look Ma, no footprints!"

remember that the cartoonist's job is not merely to create a drawing, but to make one that's funny. In this book, I will try to show you how to create such drawings. If you follow along with me, I'm sure we will have fun together.

Good luck!

Syd Hoff

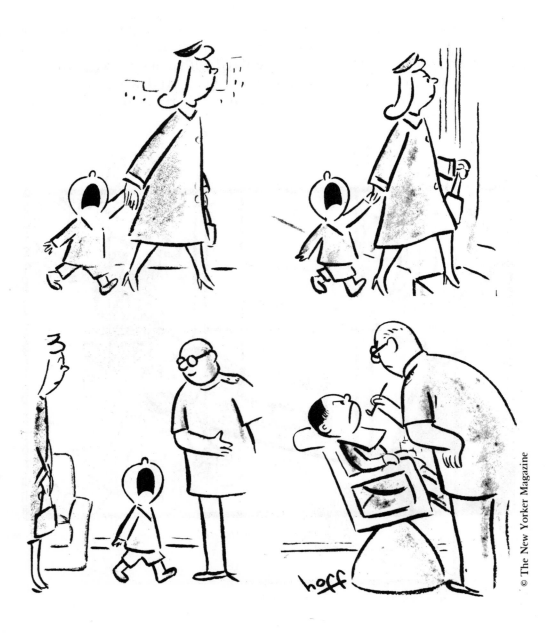

1
THE JOY OF CARTOONING

THE joy of cartooning is its freedom of expression. You may start a drawing and end it any way you want. For instance—

—a line like this—

—might become a mouse in a wall—

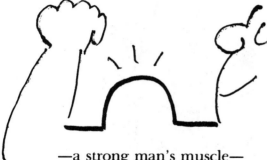

—a strong man's muscle—

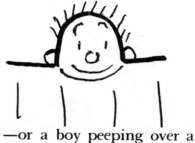

—or a boy peeping over a fence.

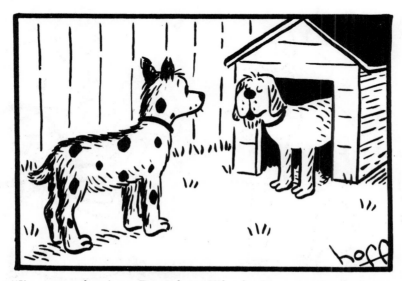

"I'm sorry, there's no Rover here. Why don't you try the doghouse next door?"

The same line might also become—

—a girl holding out her arms—

—a cowboy—

—a ghost—

—or a seal with his back to us.

Turn the same line sideways, like this—

—and you could have a lady yelling—

—a man looking around a corner—

"*How do I know what it means? Maybe it means we're welcome here.*"

—a dog barking—

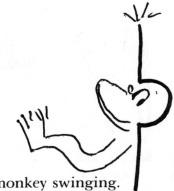

—or a monkey swinging.

The same sideway line might also become—

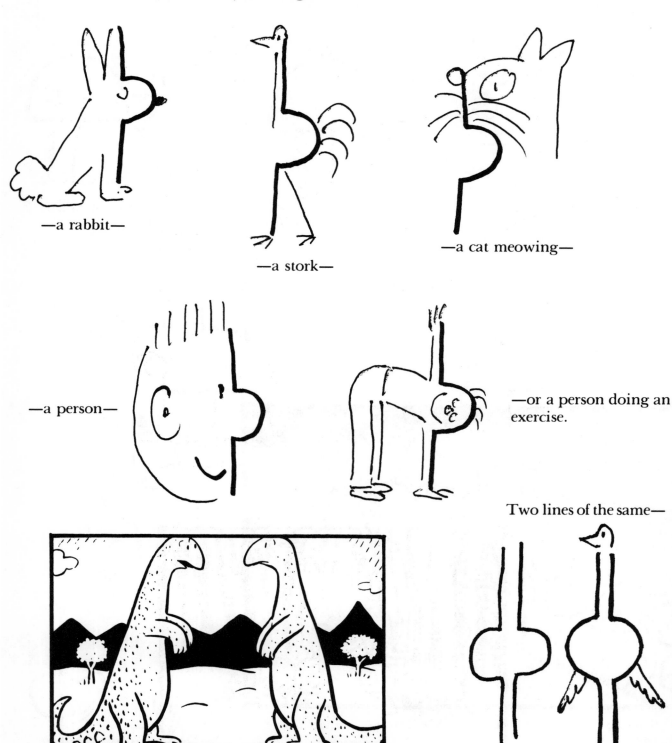

—a rabbit—

—a stork—

—a cat meowing—

—a person—

—or a person doing an exercise.

Two lines of the same—

—might become a bird.

"Lately I don't see much of the old crowd. Are we growing extinct?"

With a cartoonist, it's imagination as much as inspiration that produces interesting cartoons. That's why—

—this combination of circular, horizontal, and vertical lines could be made to be—

—a lady bending over—

—a man taking a bow—

—an animal with whiskers—

—or an insect.

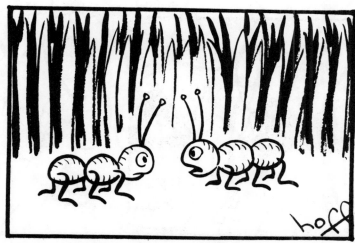

"Yes, but did you ever ask yourself, is the world worth taking over?"

With imagination a heart-shape like this can be transformed to become—

—a lady's lips—

—a mouse's face—

—an owl—

—or a boy standing on his head.

A heart upside down—

—can become a man with tight pants.

"I'm just waiting for my mother to tell me to get off her back!"

The same heart by adding a few more lines in the right places can become—

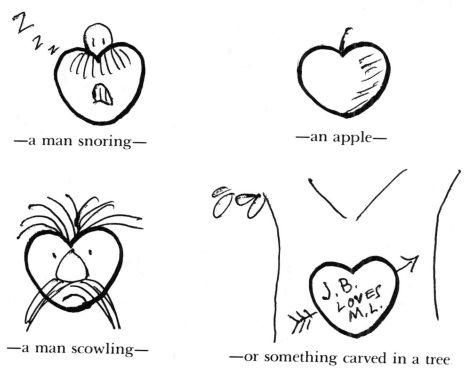

—a man snoring—

—an apple—

—a man scowling—

—or something carved in a tree

"Madam, I'm sure that to you he was just like a person, but to us he's still a parakeet."

Is there a question (mark) in your mind about all this? There shouldn't be. Just examine this page to see some of the things you can make with the question mark.

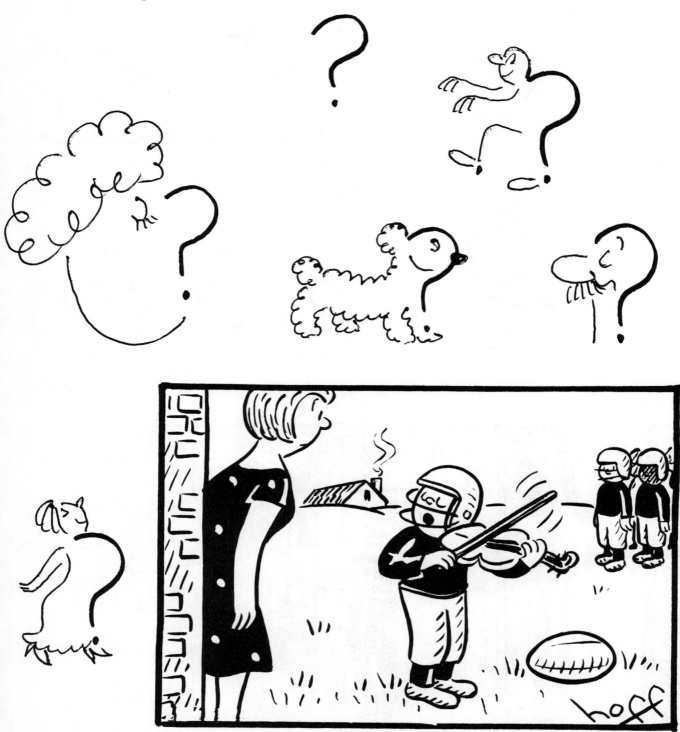

"I AM practicing."

If you give free rein to your imagination a wiggly line like this—

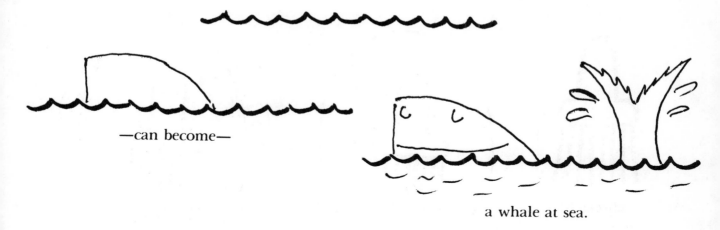

—can become—

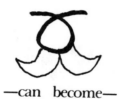

a whale at sea.

A curved line like this—

—can become—

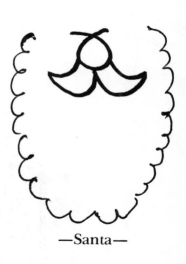

—Santa—

"Sally, when may I see your refrigerator again?"

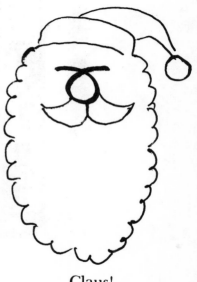

Claus!

Cartoonists are like magicians. They can make—

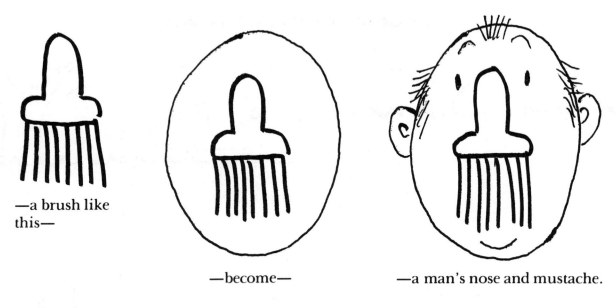

—a brush like this—

—become—

—a man's nose and mustache.

"Well, that's your opinion. I get the feeling they're pinning their hopes on me."

And this line—

—can become a chair— —with a man— —sitting in it, reading a paper!

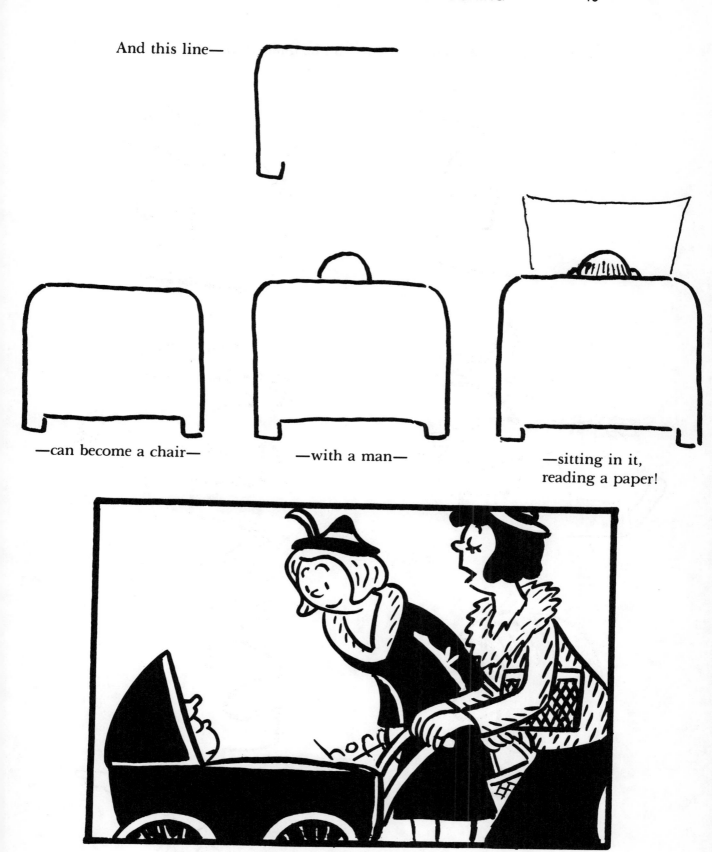

"He began to look like his father, so I changed his formula."

With a cartoonist, even crazy lines can be made into cartoons!

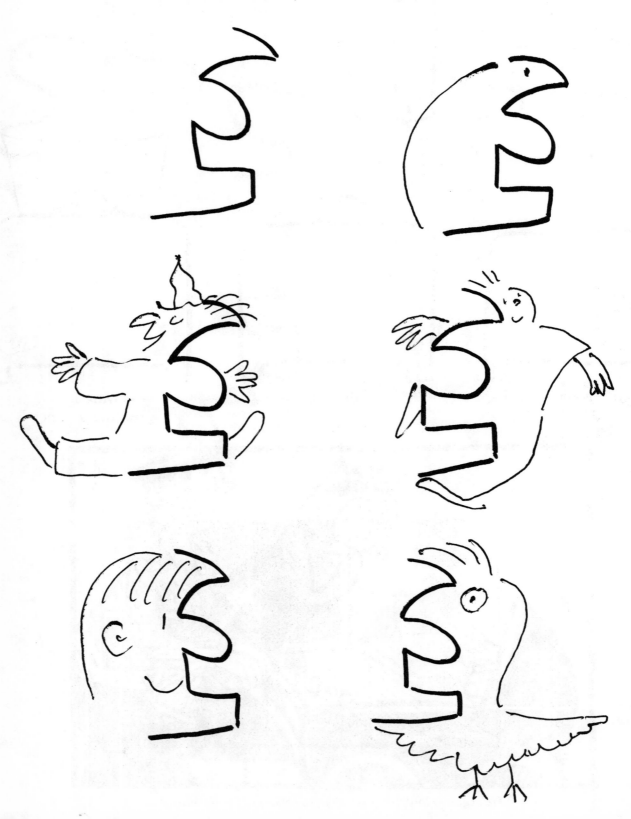

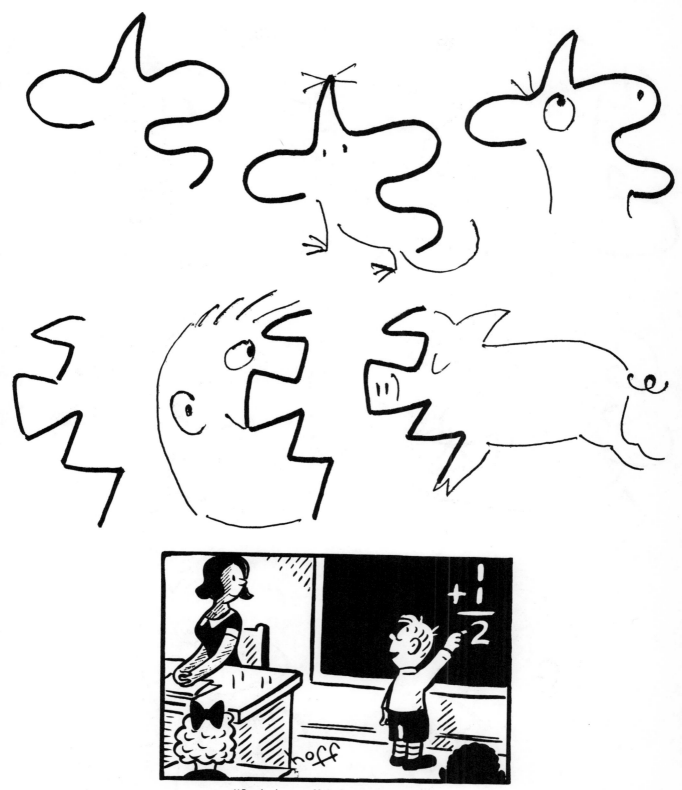

"Let's just call it beginner's luck."

Make the lines crazier and crazier!

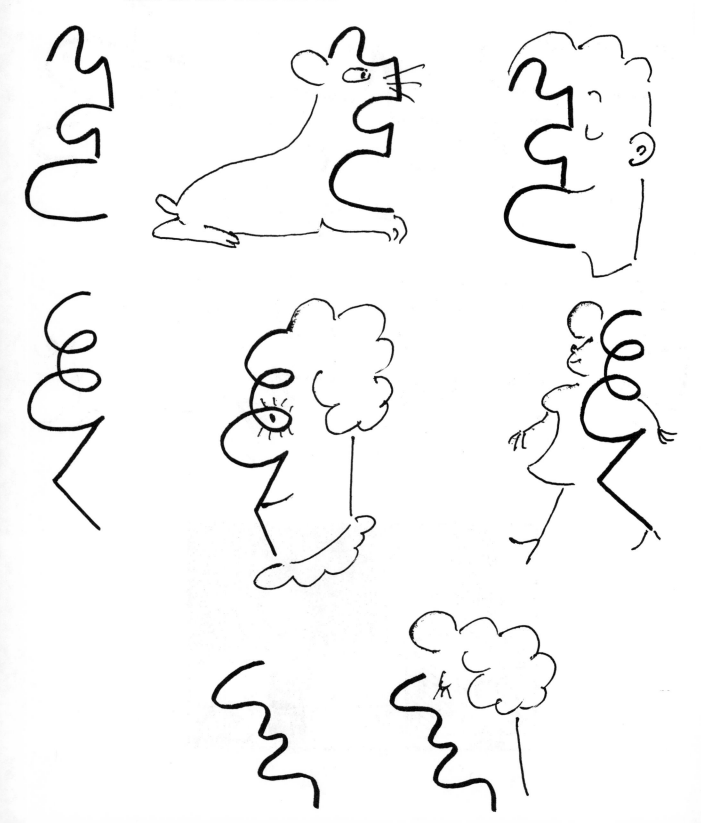

Draw all kinds of lines and try to make cartoons out of them. Sometimes your results may be far-fetched, or you may not get any results at all. But keep on trying. You'll be proving to yourself that cartooning is whatever you want it to be.

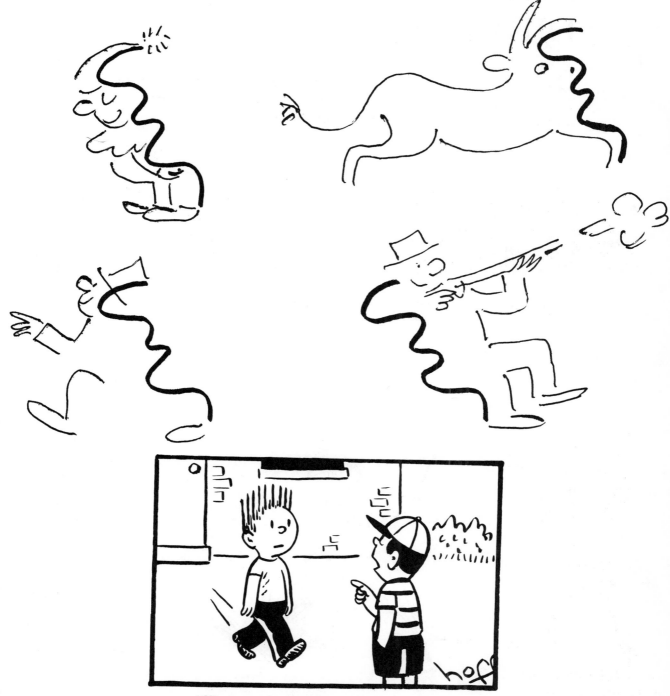

"Were you just watching a horror movie?"

2
DOODLES AND DIDDLES

Doodles are the scribblings we make when we're not aware of it. These are doodles I did recently and saved because I could see cartoons in them. Here is what I imagined they were—

—a porcupine—

—some kind of fish—

—a left-handed man making a pizza—

—a porter sweeping—

—the Statue of Liberty—

—"Hello, Dolly!"

—my foot, if I had six toes—

Sometimes I add to a doodle to make it into a cartoon.

Antlers almost gave me Santa's eight little reindeer.

Whiskers made this a cat.

All I had to add to the witch was a broom.

That star on top gave me a Christmas tree.

A cartoonist never knows where his doodles will lead.

Doodling ice-cream pops gave me this cartoon.

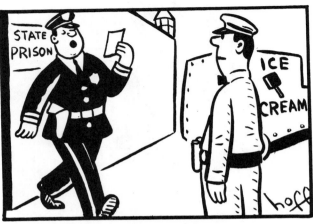

"...73 chocolate, 94 vanilla, 46 black cherry..."

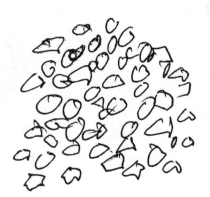

A "broken rocks" doodle led to this cartoon.

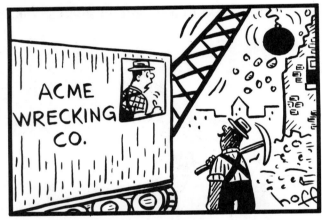

"I can't understand my children. They're very destructive."

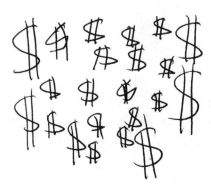

Doodling dollar signs brought this to life.

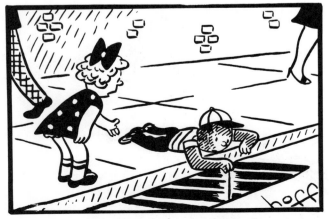

"Carlos, can't you forget this mad obsession with money?"

If I hadn't doodled this—

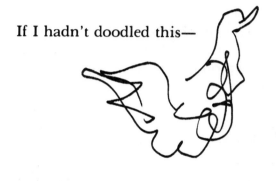

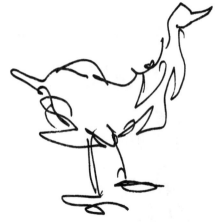

—and made it into some kind of poultry—

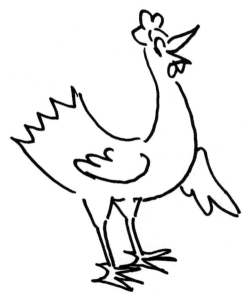

—I never would have created my favorite chicken, Henrietta, the heroine of several children's books I wrote.

Garrard Publishing Company

This is in one of my books about her.

Examine your own doodles before discarding them and see if you can turn them into cartoons.

A diddle is like a doodle, except that you know what you're doing (even
if the dictionary calls a diddle a waste of time). For example, did you
just get back from the park? Put down on paper, very roughly, what
you saw. Your sketches might show—

—a girl walking—

—a man at the wastebasket—

—a boy playing ball—

—a child swinging—

—or another child drinking.

*"We need a capable young man who's willing to start
at the bottom and stay there."*

And don't forget that you also saw—

—a policeman— —pigeons— —and an ice-cream vendor.

By any chance, did you just stay home and watch television? Put the set back on. Diddle everything you see. Be sure not to miss—

—the cowboy— —the ice skater— —the cartoons— —and the TV set itself.

And remember to draw roughly. You're not supposed to make finished cartoons yet.

3
CARTOONING ABC's

THE Phoenicians, who invented the alphabet, may not have known it, but cartoons can be made from letters. Here are some examples:

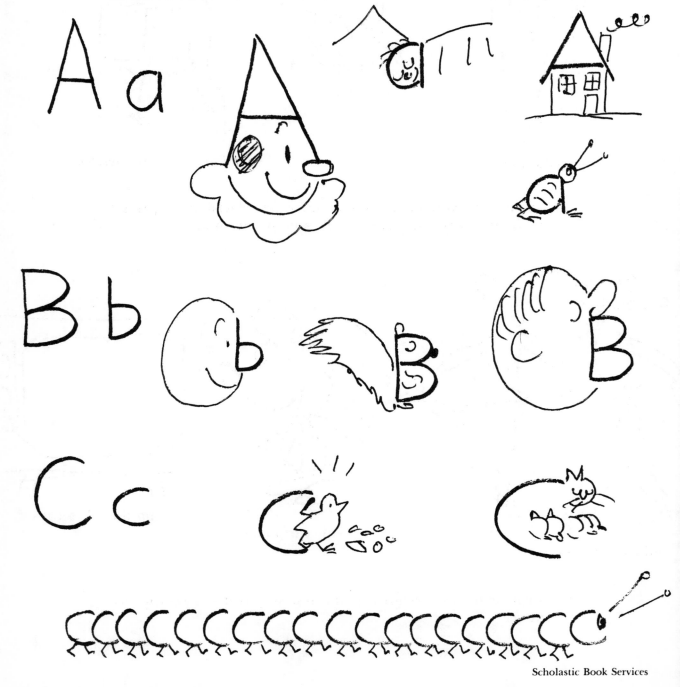

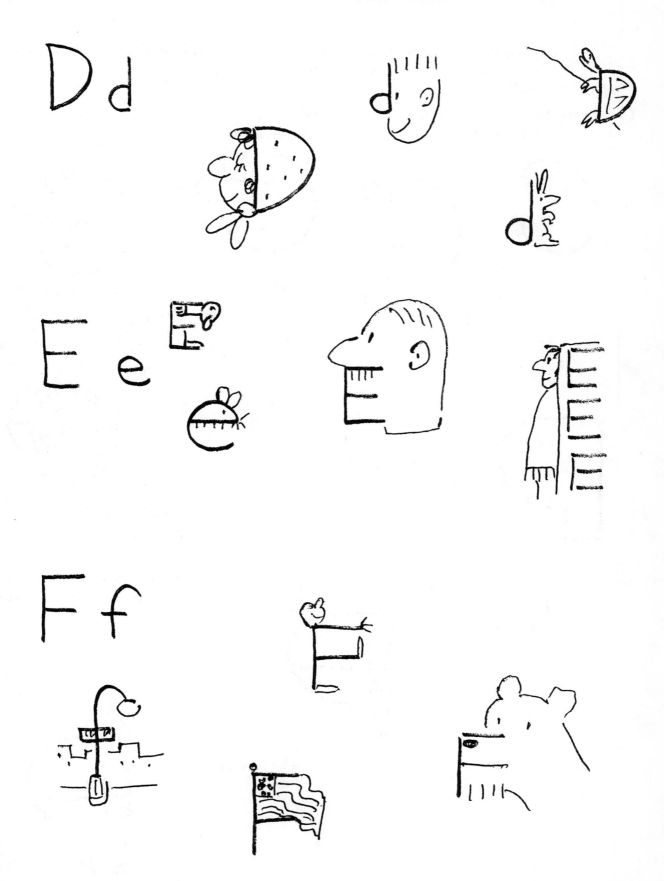

To do tricks like these with letters, a cartoonist must 'feel' his or her way. This is how one might go about converting the letter "G" into a witch.

The cartoonist starts out
with just the letter—

—adds a nose—

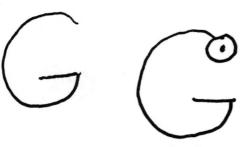

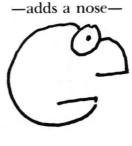

—draws an eye where one
might belong—

—then the mouth—

I can make the letter
P—

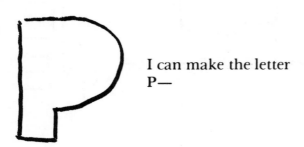

—and with a few more strokes of
the pen, finishes up with a witch!

—by adding just a
few strokes—

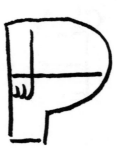

—look like my uncle
Paul.

Here are more letters and the cartoons that can be made with these letters.

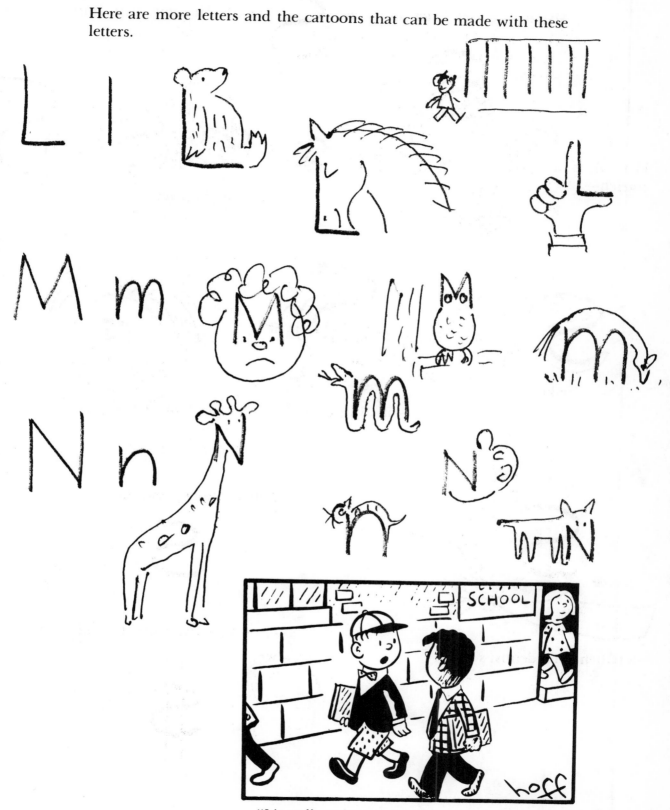

"It's really quite amazing. There are 26 letters and you can make thousands of words with them."

My favorite trick letter is this one 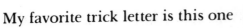 because it's my first initial.

Here it is as an ostrich—

—a school of hungry fish—

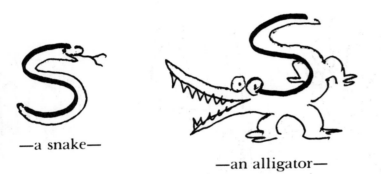

—a snake—

—an alligator—

—a part of a face—

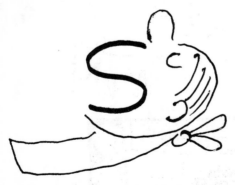

—a patient in a dentist's chair.

To make money with this letter—

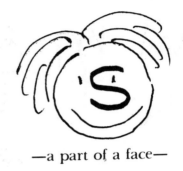

—just draw two lines through it!

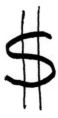

Try making your own cartoons from the letters of the alphabet! And don't be discouraged if some are harder than others!

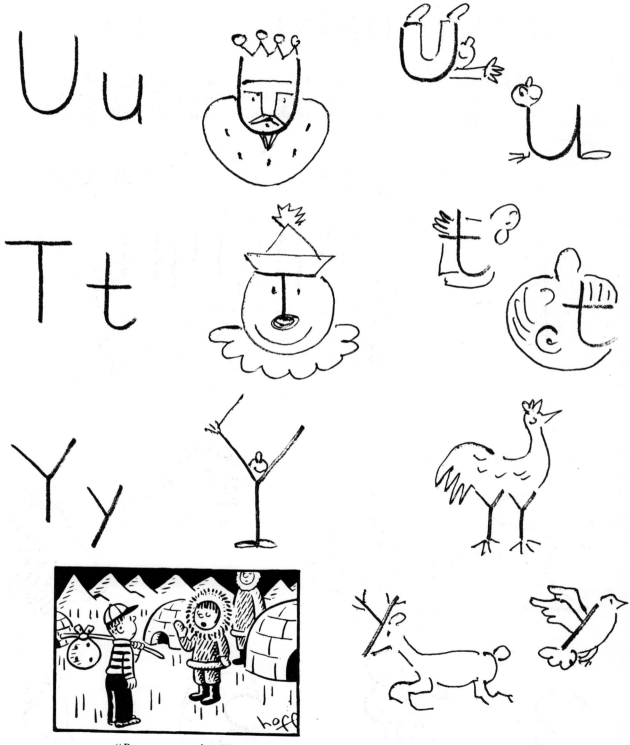

"Boy, are you lost!"

4
CARTOONING 1, 2 , 3's

Naturally, if you can make cartoons out of letters, you should be able to make cartoons out of numbers. Below and on the several pages following are examples of some of the things you can do with them.

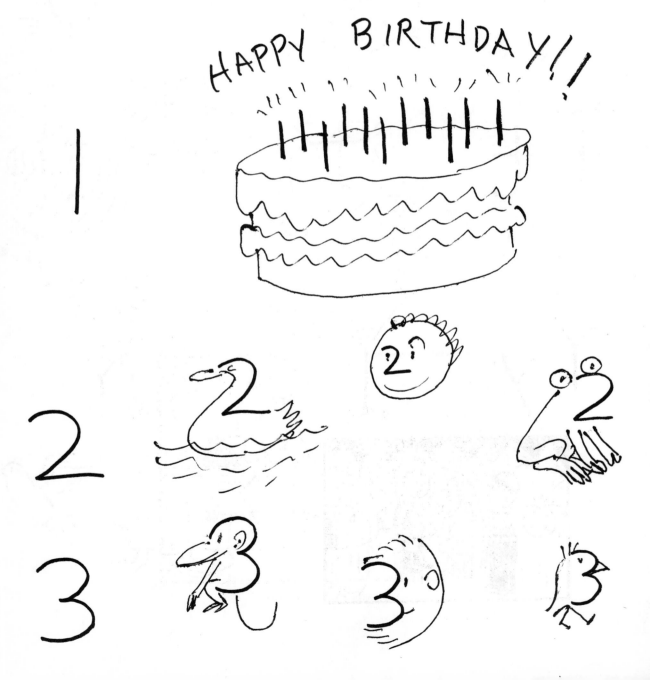

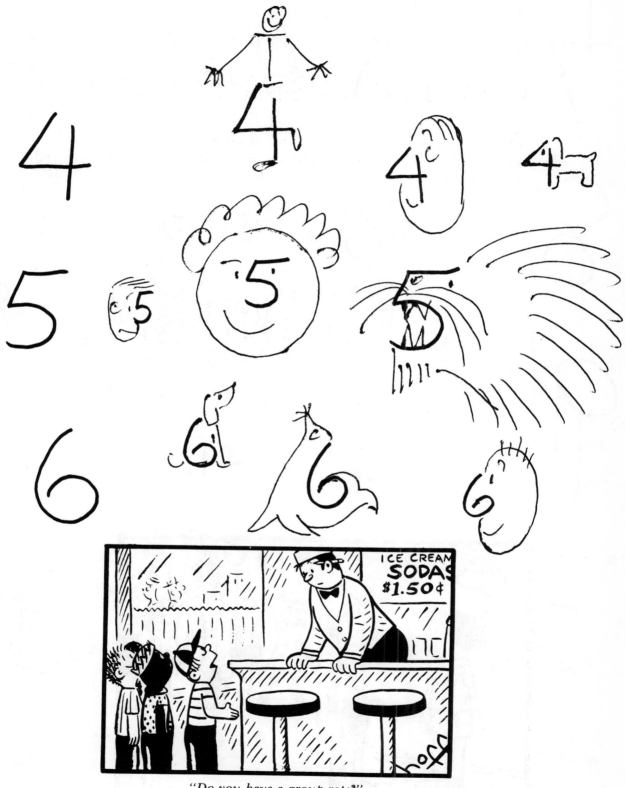

"Do you have a group rate?"

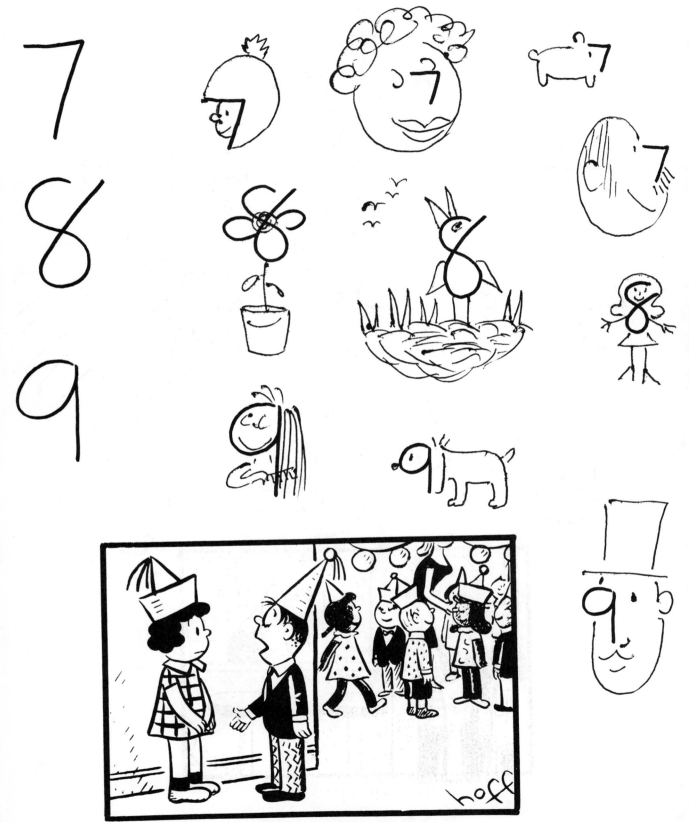

"Haven't we met before in a puddle somewhere?"

Funny pictures can even be made from a zero, or naught—
which I hope doesn't suggest there's "nothing" to cartooning.

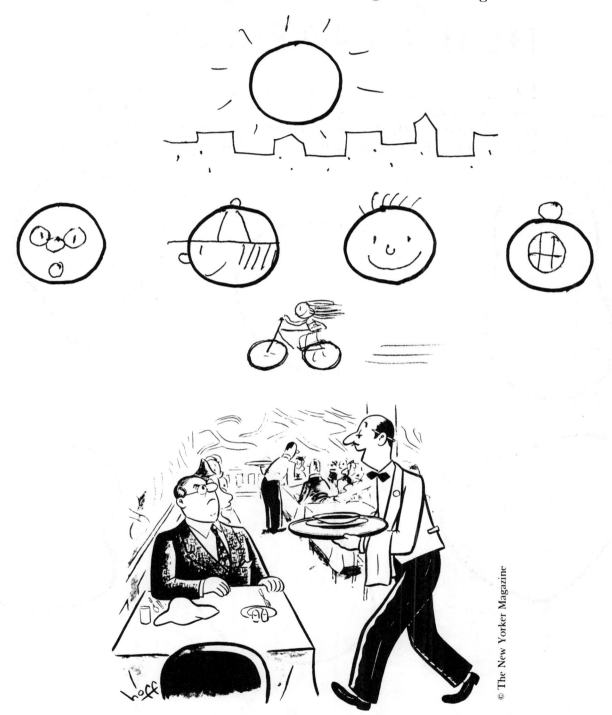

"You were right, sir. It was dishwater. The chef regrets the error."

5
HEADS AND FACES

Heads and faces come in a variety of shapes. To get an idea of the extent of this variety just look at your classmates, or the passengers on a bus. Draw any odd shape and the chances are *somebody's* head and face will fit into it. I've drawn a few below, but you can make your own.

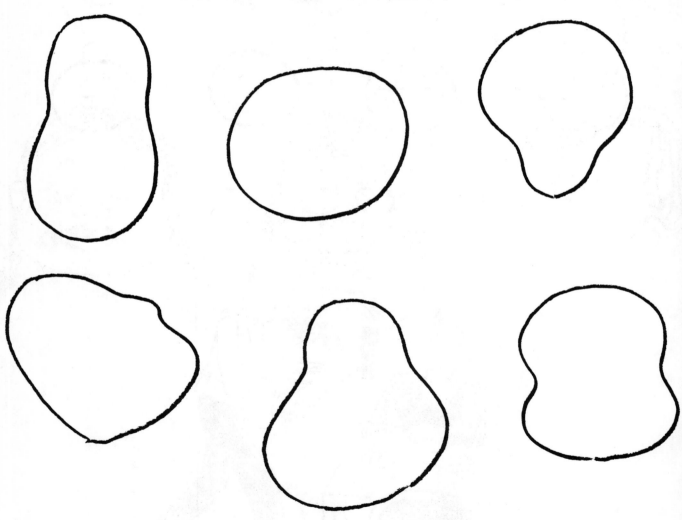

Here are my versions of those same shapes drawn as "full faces" or "front views."

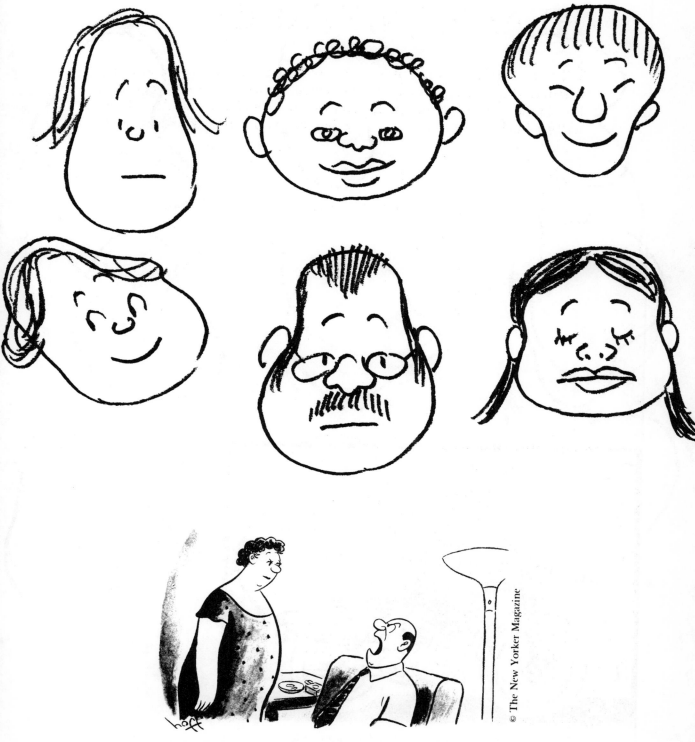

"Smile! Smile! Why can't I wear my own face once in awhile?"

Draw some more odd shapes.

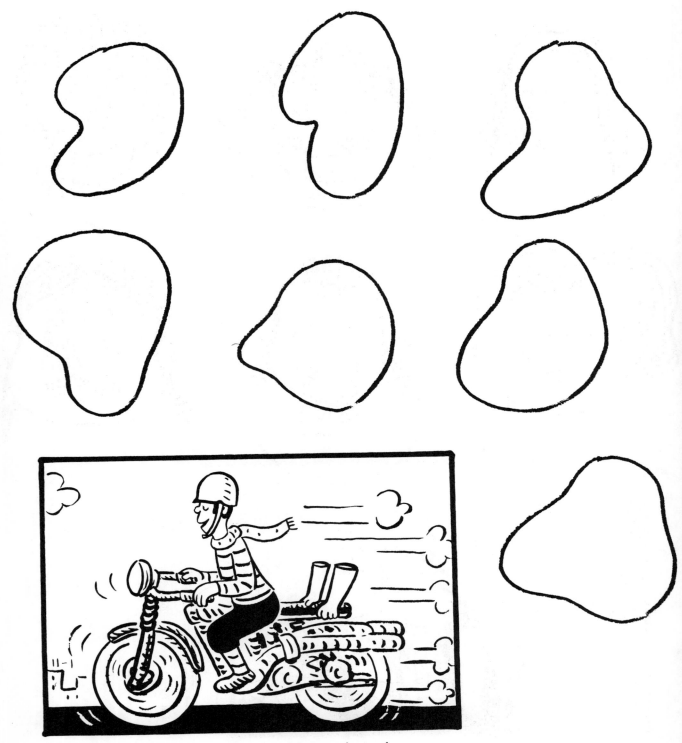

"How come you aren't complaining about the bumps, Gladys?"

This time change the odd shapes into side-views, or profiles. Below is what I made of them. Your ideas might be quite different.

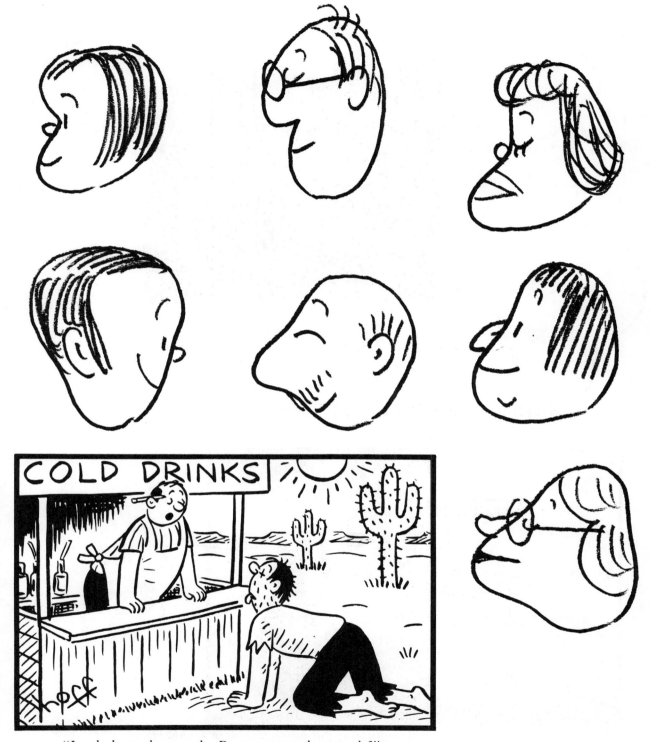

"I only have cherry soda. Do you want cherry soda?"

The elevator is overcrowded, but we can still manage to see five different faces here.

"Street floor—cosmetics, jewelry, stationery, and fresh air . . ."

You'll find several different heads in this cartoon.

"I'm afraid the cupboard is bare again, Mrs. Hubbard."

Heads and faces are different, and so is the thinking in the case of these two girls.

"When I asked what you're going to be when you grow up, I didn't mean what color hair you'll have.

The bird in this cartoon has a distinct head and a mind of his own, too.

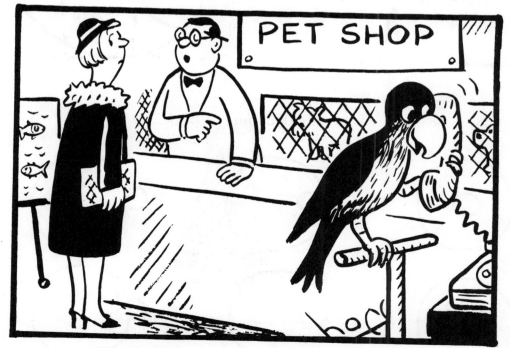

"It's a long distance call to his family in the jungle."

Ancient rules laid down by cartoonists long ago, called for a head and face to be divided into sections—

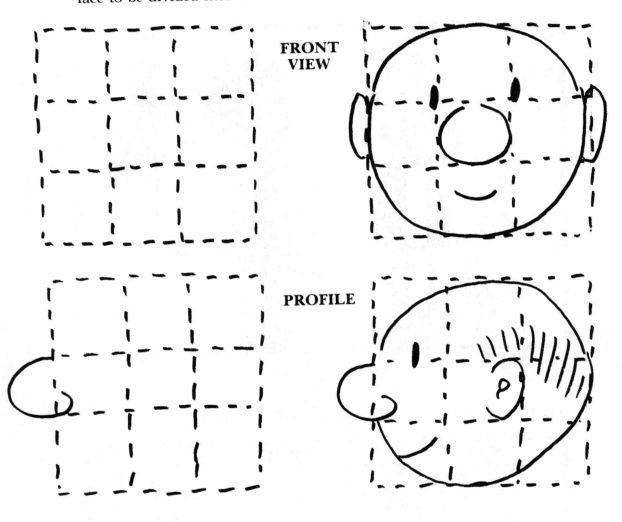

FRONT VIEW

PROFILE

—or to be done, starting as a doughnut or bagle.

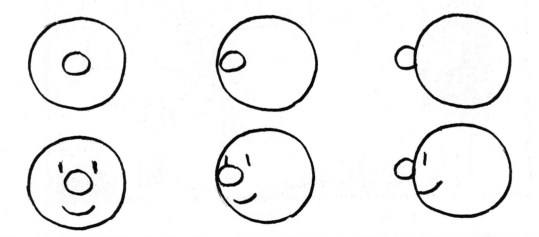

In modern cartooning, however, anything goes (as long as it's funny), so draw away.

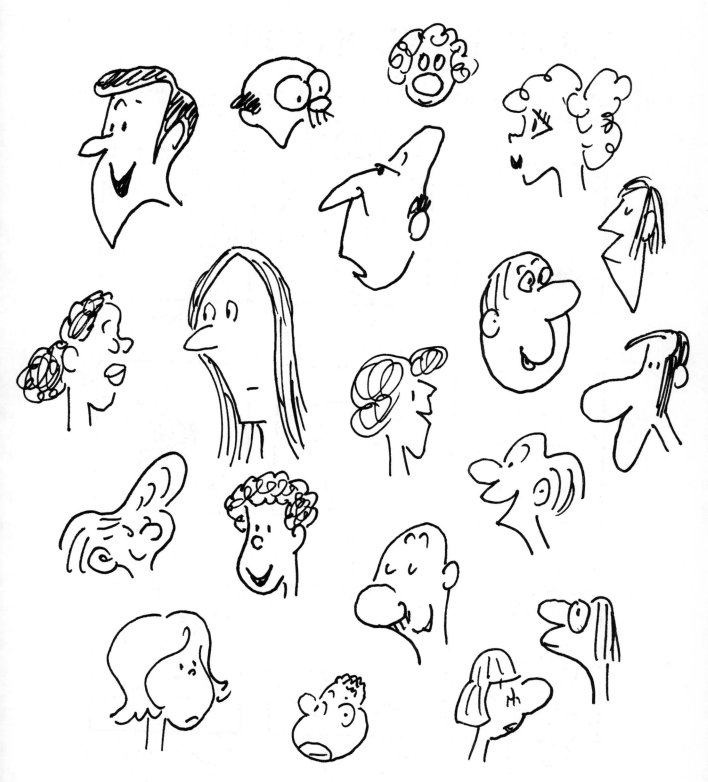

6
NOSES AND STUFF

Whether we follow the rules or not, it's a good idea to take stock of features.

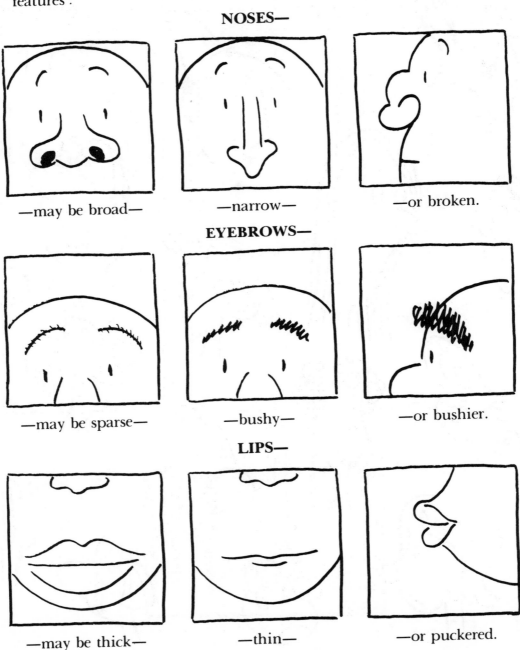

NOSES—

—may be broad— —narrow— —or broken.

EYEBROWS—

—may be sparse— —bushy— —or bushier.

LIPS—

—may be thick— —thin— —or puckered.

HAIR—

—may be curly— —straight— —or gone.

EYES—

—may roll— —wink— —or need glasses.

EARS—

—may be large— —small— —or cauliflower.

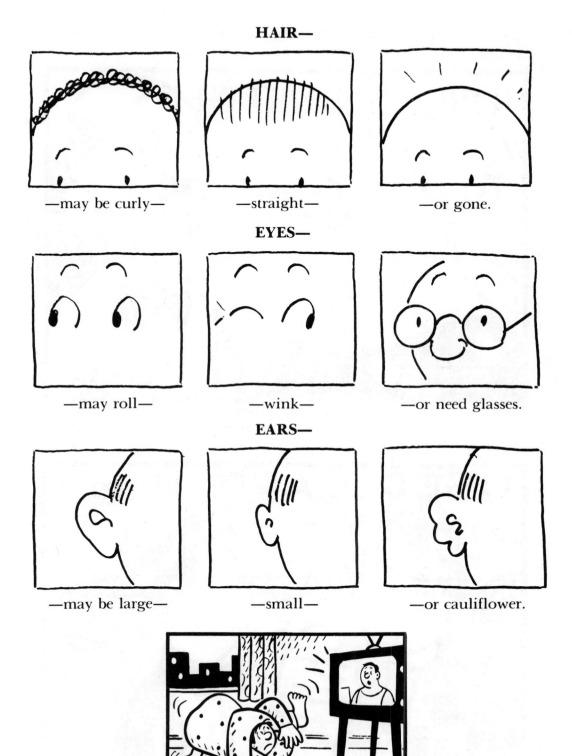

"I must apologize, viewers. I seem to have made an error in that last exercise."

The faces in the cartoons on this page and on the ones following do the "selling."

"Of course you're entitled to an opinion. What kind do you want?"

"Son, what do you mean you'd like to try it out? Don't you trust your own father?"

"Forget the 'Once upon a time' and tell me something contemporary!"

"How can we eat, drink and be merry at these prices?"

"Then the woman driver ahead of me that I kept yelling at, turned out to be a man."

The young lad had to seem honestly confused.

"Yes, Sir Walter Raleigh put down his jacket for a lady to step across a puddle, but first he got out of it!"

The man in the cartoon below couldn't look like much of a reader, inspite of the newspaper.

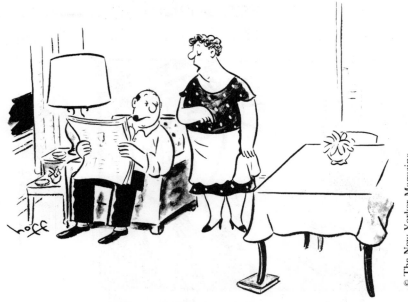

"You simply got to do something about the table. The third notice from the library came this morning."

"It's a good thing for you I like mashed potatoes!"

"So far all they've restored is the youthful look of my bank account."

"It's a very sad case. He also broke an $1800 watch."

"Table four doesn't like the soup!"

The patient had to be showing more pain in this cartoon than his wife.

"Oh, we're all just fine, thank you. How are you all!"

More "faces of importance."

"Don't worry, Sir. I happen to be the best outfielder on the club."

"It's my duty to warn you that anything you say will be taken with a grain of salt."

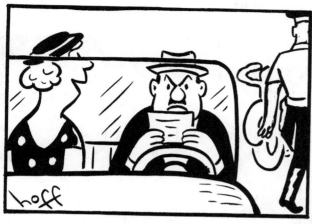

"My, wasn't he handsome!"

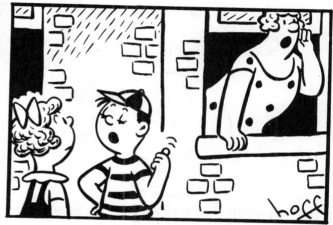

"That's the woman in my life."

Keep your cartoon faces simple. Avoid unnecessary details.

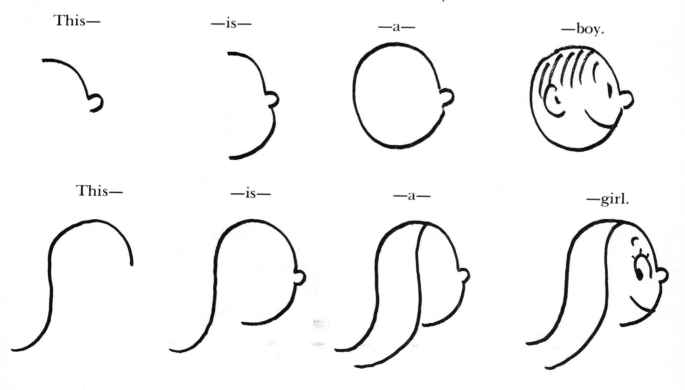

7
LOOKS COUNT

W E don't have to take a person's temperature to find out how he or she feels. All we have to do is look at the facial expression.

Good marks on a report card

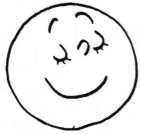

Sublime happiness is best shown by closed eyes and a broad smile.

Not such good marks

Disappointment comes through with the roll of those eyes and a dour mouth.

"Yes, you may go out on a date tonight."

Great news! Happiness shows in the eyes and mouth.

"Just be home by nine o'clock."

Eyebrows and mouth combine to show that this is news of the very worst sort.

"Hoo-ray! Our basketball team won!"

Sheer ecstasy! The broad smile and open mouth say it all.

"Darn! We lost again!"

Sheer anguish this time. Study those eyebrows.

"You say Big Butch is looking for me?"

Stark terror show in the eyes and mouth and every feature except the nose.

"Oh, it was only little Leroy."

Sheer relief! This person is sighing and you can almost hear it.

"I'll never have children of my own."

A look of superiority by one who obviously looks down at the human race.

"Ooh! Look at that cute baby!"

Love conquers all, as we can see in everything about this face.

The wrong expression can ruin a cartoon.

RIGHT

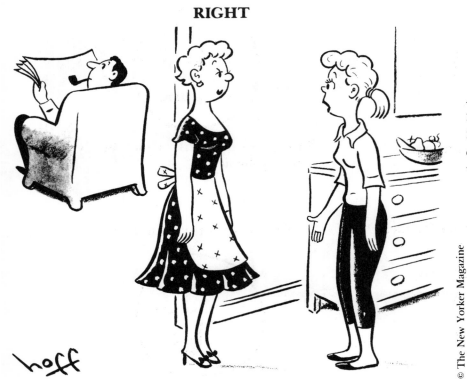

A remark made in pure innocence and with the right facial expression, as in this cartoon, can strike readers as very funny.

© The New Yorker Magazine

"Do you mean to tell me you and Daddy were once teenagers?"

WRONG

However if the teenage daughter were laughing at her parents, readers would have no use for her at all, and the humor would be lost.

RIGHT

"Do I have to wash? I'll only get dirty again later."

WRONG

The boy couldn't be yelling at his mother, or he'd seem nasty as well as unsanitary.

RIGHT

"Well, I've dried all the dishes except two that won't ever have to be dried again."

WRONG

The girl couldn't look unconcerned about what happened in the kitchen.

This vendor couldn't help losing patience with his young customer as he considered the problem of malnutrition on Earth.

"In certain parts of the world, they wouldn't care if it wasn't plain chocolate WITHOUT the sprinkles."

The boy in this cartoon couldn't enjoy being used as a writing pad.

"I didn't know what you meant when you asked if you could count on me."

A mild expression on an employer's face helped make bad news bearable.

"Look Benson, I don't want you running in here every five years asking for a raise!"

Contrarily, the employer in this cartoon had to be choking with rage.

"I'm sorry, he's tied up right now but he said to double everybody's salary."

The wife had to look stronger than her husband in this case.

"Is he strong enough to know how much all this is costing us?"

A rare gag line gave me a chance to use two expressions on the same face in this cartoon.

"Alfred is semi-retired."

The fighter's footwork is important but so are his expressions as he suffers a knockout from an unexpected source, in this rough sketch for a cartoon.

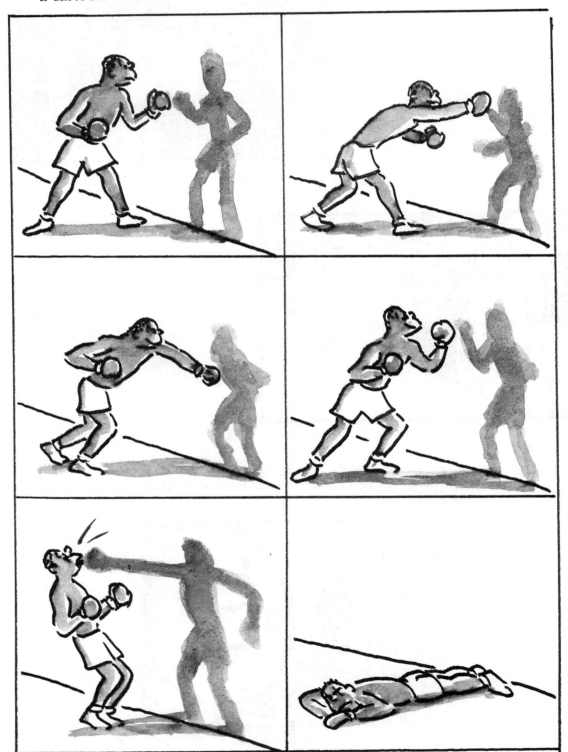

No buck private dares look at a sergeant with anything but a straight face.

"May I speak frankly?"

"Beatrice!"

Blissful was the way I had to make that lady.

Down through the centuries, art lovers have worshipped the expression in Leonardo da Vinci's famous painting of the Mona Lisa.

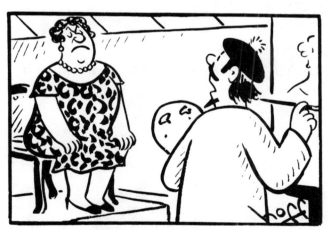

"Yes, Mrs. Grimshaw, I'd like to make you look like Mona Lisa, but you'll have to help.

Naturally, I had to show Mrs. Grimshaw with something other than a "mysterious smile" in this cartoon.

Often a cartoonist ponders a situation a long time before drawing the characters. The problem here: to show a dentist gone berserk in his office and holding a patient against his will. Should the dentist be shown—

—yelling loud enough to be heard a block away—

—baring his own teeth in a maniacal grin—

—giving signs of being guilt-ridden—

—being ashamed of his crime?

Should the patient be calm and stoical, resigned to his fate—

—or be threatening a law-suit?

—grin and bear it—

This is the way I finally did the cartoon.

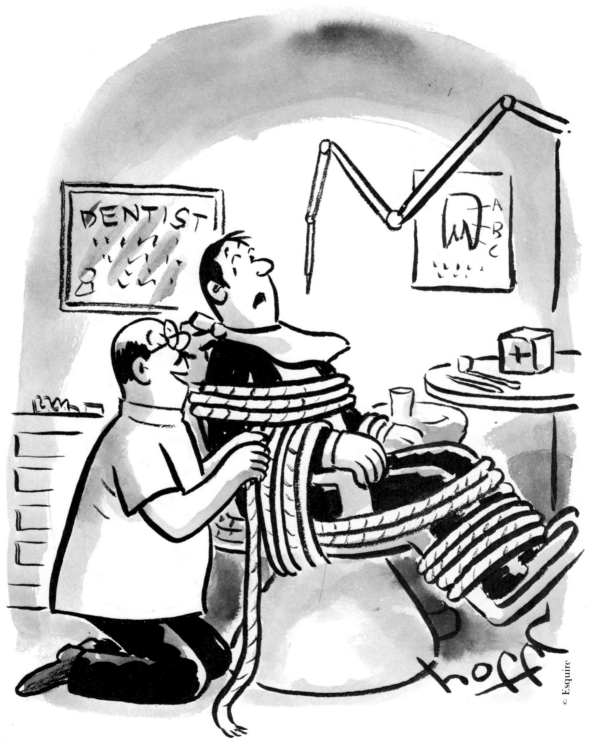

"Just relax—this isn't going to hurt a bit."

I had an idea for another cartoon with a problem: how to draw a lady whose convict husband has just escaped from jail and immediately begins complaining about her cooking.

Should the lady wear a patient smile?

Or should she be talking back to him in no uncertain terms?

Perhaps she should cry and carry on?

Or do you think that she should turn her back and ignore him?

For awhile I thought to show her looking up at the ceiling and sighing.

I also considered showing her trying reasoning with him.

And then just letting her husband have it.

In the finished cartoon, I decided it would be best if the lady just talked quietly and everything was kept low key.

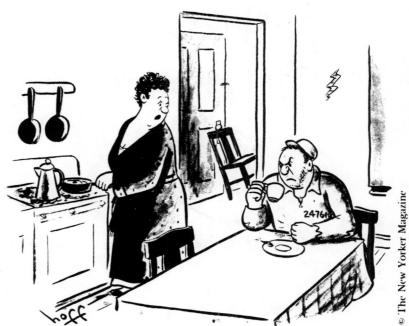

"I'll bet you never complained to them about the coffee?"

8
THE EXPRESSION TEST

Can you tell how people would look if they heard the following lines? (Answers on bottom of next page.)

A B

One

"Here's your bike back, Herby, I bent both wheels."

A B

Two

"My, how pretty you are lately, Rosalie!"

A B

Three

"We're sorry, Freddy, we're only giving you half your allowance this week."

A B

Four

Ooh! There's a spider on your head!"

A B

Five

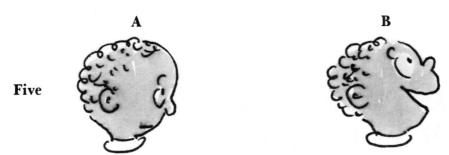

"I just looked at your examination paper, Monroe, and marked it a hundred percent."

A B

Six

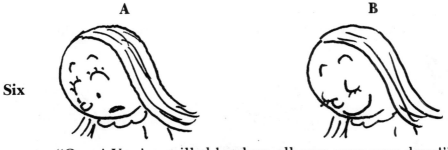

"Oops! You've spilled ketchup all over your new dress!"

A B

Seven

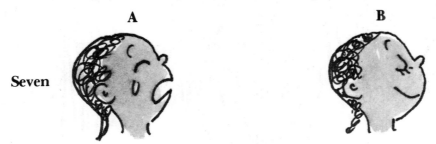

"I'm afraid your pet goldfish isn't moving, dear."

Become an actor! Study your face in the mirror and try to register all kinds of expressions from friendship to hostility. Draw what you see in the mirror.

Answers

(One B, Two A, Three B, Four A, Five B, Six A, Seven A)

9

CLOWNS AND CARTOONS

CLOWNS are cartoonists who use their faces and expressions to make
funny pictures. Cartoonists create similar funny faces, but on paper.
Here are some drawings of clowns you might have seen at the circus.

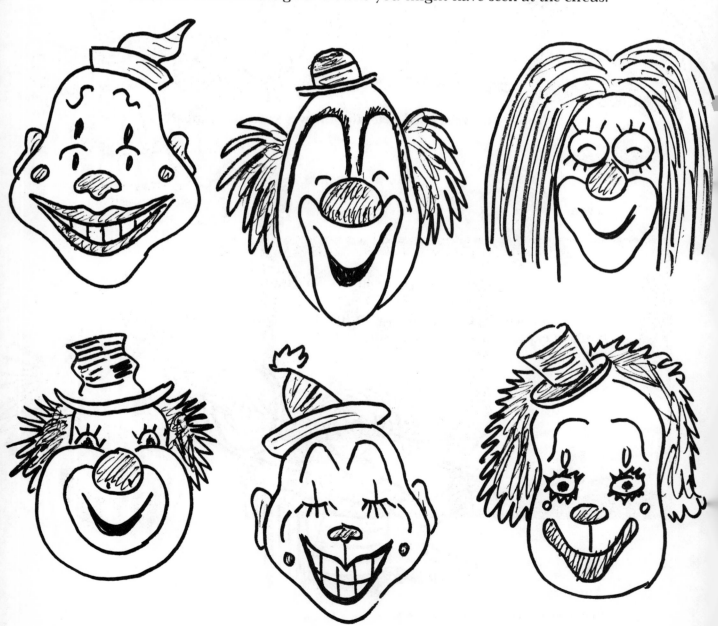

Drawing clowns' faces is a good exercise for the beginning cartoonist because clowns exaggerate their expressions. Look at the faces below and try to draw similar ones. Let your imagination go!

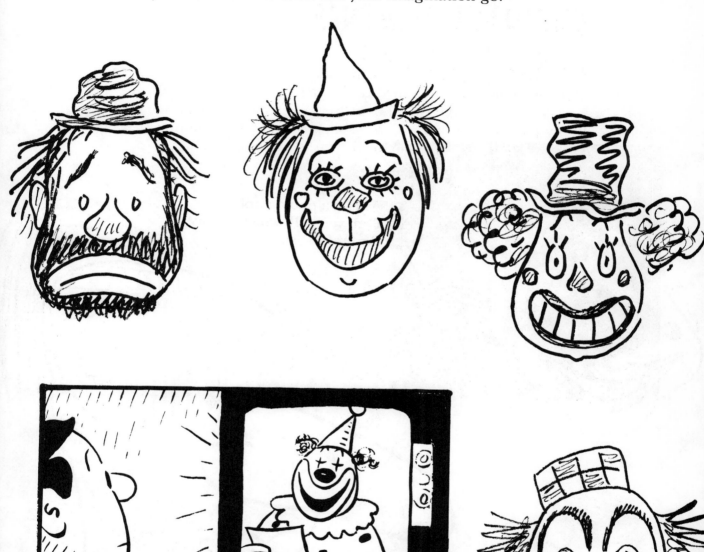

"And now for the lighter side of the news."

10
FUNNY FACES

Cartoons of people in which a likeness is captured by exaggeration, or impression, are called caricatures.

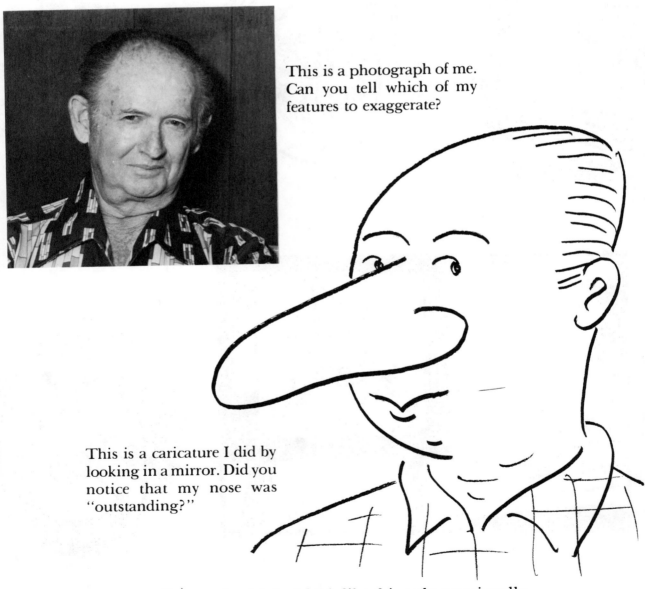

This is a photograph of me. Can you tell which of my features to exaggerate?

This is a caricature I did by looking in a mirror. Did you notice that my nose was "outstanding?"

My wife says she thinks I look like this only occasionally.

These are caricatures I made of various friends.

Joel has bushy eyebrows and a slightly protruding lower lip.

Bernice is noted for her toothy smile.

Herb's ears are the first things you notice about him.

Armando's nostrils resemble the entrance to a tunnel.

Here are caricatures of other friends of ours.

Henry is famous for his big appetite.

Isabel should really have a "nose job."

Clement's chin is weak and one front tooth appears to extend over the lower lip.

Harriet looks like she never goes to a hairdresser.

Mickey reminds you of his namesake the rodent.

Rolf has a large double chin.

Are you satisfied with my carica-
ture of George Washington? I hope
so.

Sara seems painfully thin.

Albertina is proud of her blue eyes.

Try to make caricatures of your friends, but try to be funny, not mean.
People can feel very hurt if they think that you are ridiculing them.

"Sorry, we have no openings right now."

Cartoonists rarely get a chance to do a serious drawing. I did this portrait of Henry Bergh, who, way back in 1866, founded the American Society for the Prevention of Cruelty to Animals (ASPCA). I did the portrait in order to get myself into the mood for doing a book about him. The book is entitled, *The Man Who Loved Animals*. Notice that in spite of my efforts to do a "serious" drawing, I could not entirely lose my cartoon style.

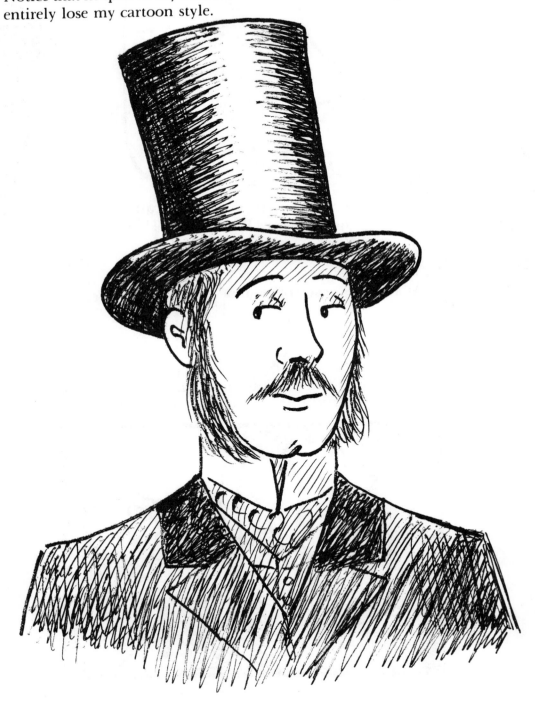

In these sketches for the book, Henry Bergh shows mixed emotions as he—

—orders a peddler to stop beating his horse—

—rejoices at having people thrown into jail for being cruel to children, as well as to animals—

—scolds those who insist on wearing hats decorated with birds' feathers and coats made of animal furs.

© Coward, McCann

Called "The Great Meddler," this man taught us to be kind not only to animals, but to each other.

Cartoons are often used for book illustrations. In this rough sketch for Louise Armstrong's book, *Arthur Gets What He Spills,* I show what Arthur got for his birthday when he spelled party as P-O-T-T-Y.

"S-P-A-G-H-E-T-T-I"

In this preliminary cartoon sketch the whole family rejoices when Arthur finally spells a word correctly.

The finished cartoon shows Arthur's utter pleasure as he enjoys his prize.

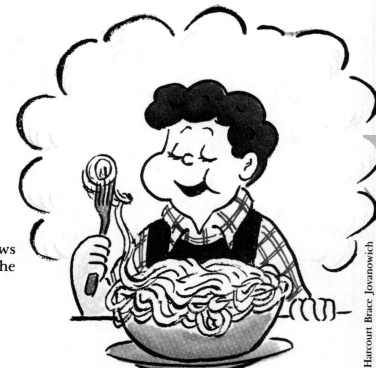

Harcourt Brace Jovanowich

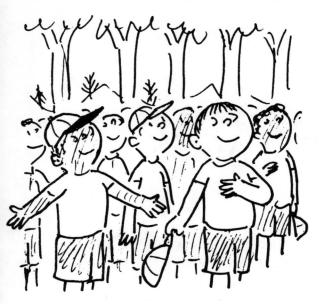

In sketches for *Jeffrey at Camp,* the young campers inhale the fresh country air with deep-breathing exercise.

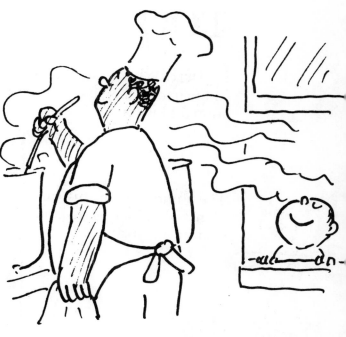

Jeffrey however shows just as much enjoyment smelling the air in the kitchen, as the chef cooks.

Here he is writing home for a salami and anticipating the pleasure of eating it.

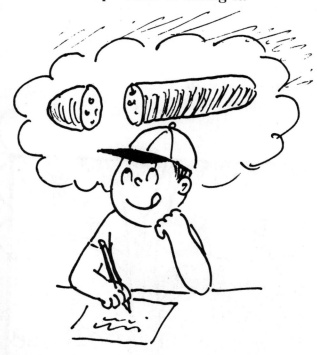

Another hero of mine registers ferocity as he himself turns into a king of beasts in the book, *Wilfred the Lion.*

G.P. Putnam's Sons

11
ANIMALS HAVE FACES TOO

Cartoonists can't help it. Just as they exaggerate the human countenance, they have to do the same with various members of the animal kingdom.

The rhinoceros in this cartoon had to look as shy and demure as possible.

"Stop telling me I'm cute when I'm angry!"

In this drawing, from *Slugger Sal's Slump,* a mascot cat shows its disapproval of a frustrated young ball player.

"How can he be so happy when we're an endangered species?"

80

Sammy, the hero of *Sammy the Seal*, is delighted as he takes off on a day's vacation from the zoo.

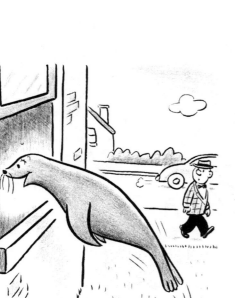

Here, Sammy, thirsty and wanting to cool off, leaps through an open window of a house seeking water.

But Sammy is disappointed as he is chased out of the bathtub by the owner of the house.

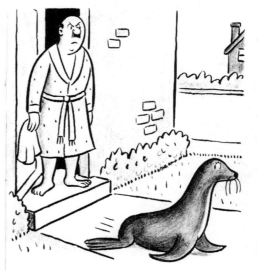

"I demand a rematch!"

Harper & Row

In this sketch I did for *The Snake That Couldn't Slither* by Peggy Bradbury, the reptile hero, Simon, looks on jealously as his friends frolic.

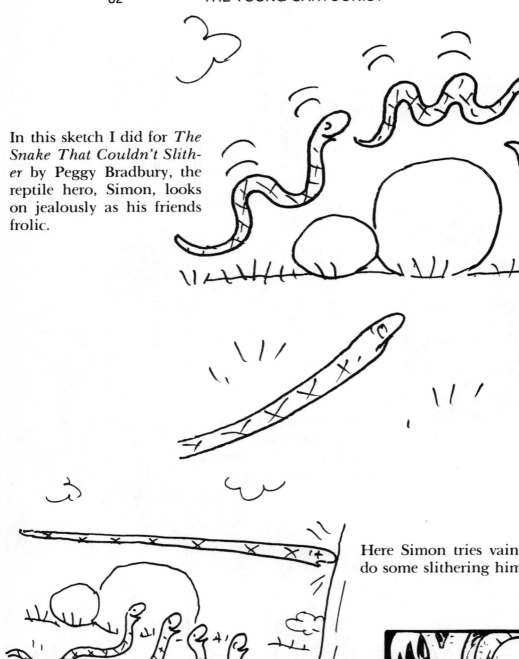

G.P. Putnam's Sons

Here Simon tries vainly to do some slithering himself.

"Don't be silly. Just try to remember what's IMPORTANT."

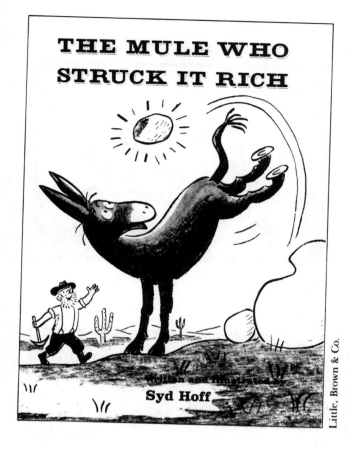

The hero of *The Mule Who Struck It Rich,* a not-so-dumb animal, registers joy as he discovers new wealth.

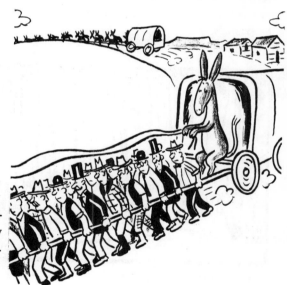

In this cartoon, he risks being called *nouveau riche* by turning the tables and driving a twenty-*man* team.

And here he entertains less fortunate friends at his sumptuous mansion.

An assortment of animals, domestic and otherwise, do their best to provide humor in these cartoons.

"First brush your hair, THEN tell me you want to be friends."

"He's very jumpy lately."

"One thing about getting up late—there's less chance of the early birds getting us."

"I don't trust him. He's a little too sly."

"Let's ask him directions."

"For the last time, stay out of our act!"

"I know what I'm doing! I'm over a hundred and twenty-one."

"Go straight ahead to some broken bottles, then look for it on your right, near the pile of garbage."

"No, you can't keep him!"

"He just wanted to remind us to bring home a doggie bag?"

"What kind of people do you hope will win you in a raffle?"

"I'm sorry, you have to PAY for them!"

"Now, what shall we put here for bait?"

"No, I don't want to play leap frog. Don't you know any other games?"

"Believe it or not, I just met a girl named Goldilocks."

"I'm new here myself."

"Whenever I can't sleep, I count people."

"If you want something, ask for it. Don't bark."

"Swing left and it's the third tree you come to."

"I've got moths."

"Are we supposed to get the sniffles?"

"Do you live here, or are you just migratory?"

To do cartoons of animals, it isn't necessary to track them to their native habitat. Simply pay a visit to a park, a farm or your neighborhood zoo. The animals may even stand still long enough for you to draw them.

Animals make good cartoon subjects, so you will find more about them later in this book.

12
FUN WITH FIGURES

THE human figure comes in a variety of sizes and shapes, as we can see in these silhouettes.

TALL

SHORT

FAT

LEAN

"We need someone who is interested in room at the top."

A man can stand erect— —slump— —keep his legs close together— —or look as if he just got off a horse.

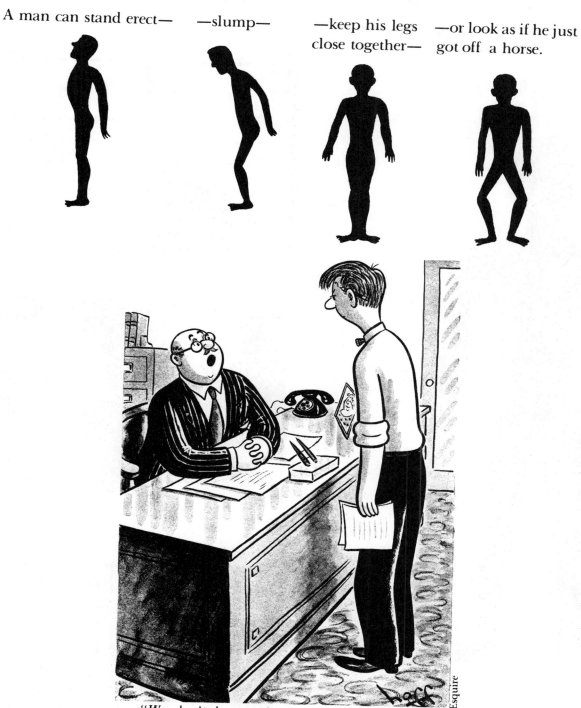

"We don't know what we'd do without you, Carruthers, but we'd rather."

If we had to apply a rule for the human figure, we would have to say it is about six heads tall.

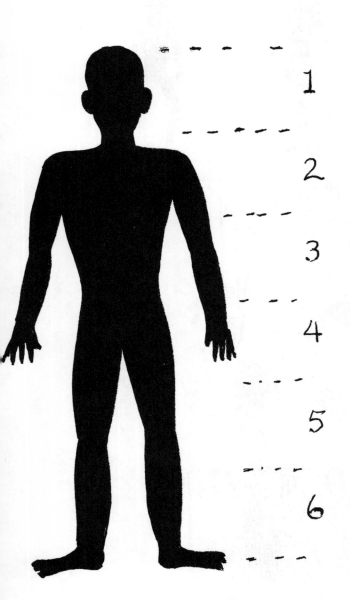

1

2

3

4

5

6

"I like him, but not as a steady diet."

"Are you afraid of height? He's got a friend who's six-ten."

"I can't understand my kid. He doesn't want to go into my line of work."

But again, as with heads and faces, we don't have to follow any rules.
Figures may be—

—1½ heads tall— —2 heads tall— —3 heads tall, or— —oops! a basketball player!

Draw them tall— —short— —medium—

—draw them any way you want—

—as long as they look reasonable and are funny.

"Who's dancing? I just stepped on some molten lava!"

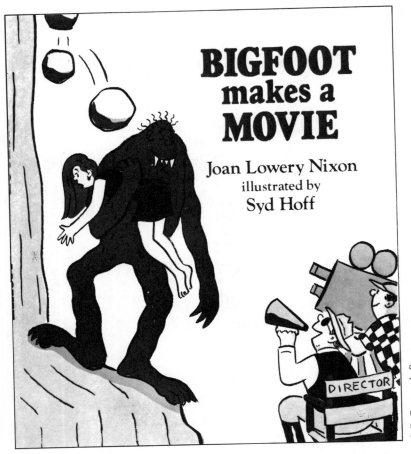

BIGFOOT makes a MOVIE

Joan Lowery Nixon

illustrated by

Syd Hoff

G.P. Putnam's Sons

In Joan Lowery Nixon's book, *Bigfoot Makes a Movie*, the sky is the limit for our main character.

This sketch for the back cover shows a bird possibly trying to estimate the size of Bigfoot's shoes, that is, if he wore any.

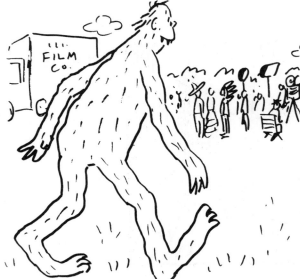

A small head emphasizes Bigfoot's tremendous height as I show him leaning over to fit on a page.

In cartoon sketches for Allan Sherman's book, *I Can't Dance,* I had to exaggerate again.

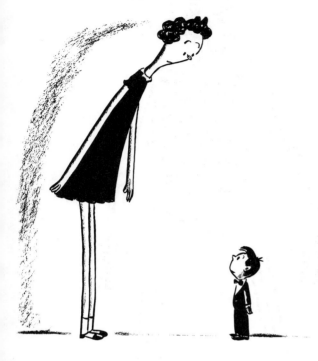

At a dance the bashful boy imagines himself far too short for a girl.

 Harper & Row

This is what happens when the boy gets over his shyness.

"Psst . . . a penny for your thoughts."

13
THE X-RAY TREATMENT

LET'S take another look at the human figure, but with a cartoonist's X-ray eye this time.

To study this figure, we will need seven toothpicks, two shorter than the rest.

"I guess he's been canned."

"That's not fair, Dad, you're hitting me below the belt."

Arrange the toothpicks this way.

Now break four toothpicks in half, to indicate arms and legs.

"We brought along some glue, in case they break anything."

Sketch in, or imagine hands, feet, and a head, to remind yourself that this is a human figure.

We are now ready to give life to our toothpick figure.

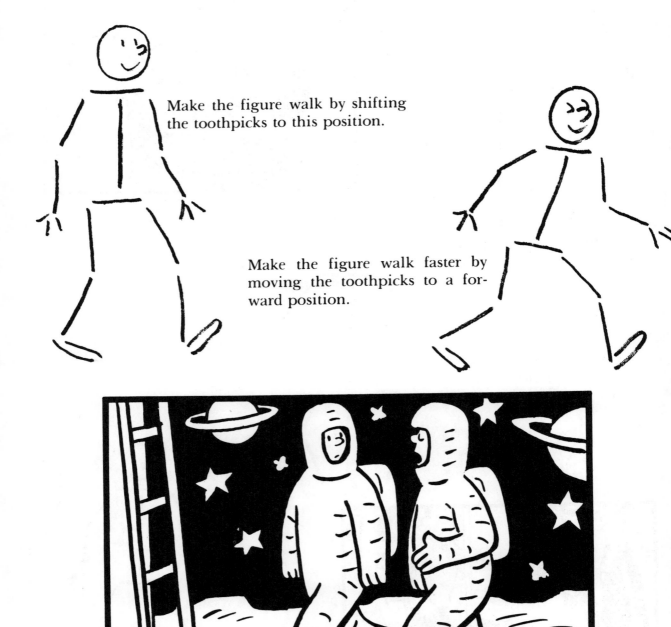

Make the figure walk by shifting the toothpicks to this position.

Make the figure walk faster by moving the toothpicks to a forward position.

"Now for the hard part—going back and telling my kids I didn't bring them anything."

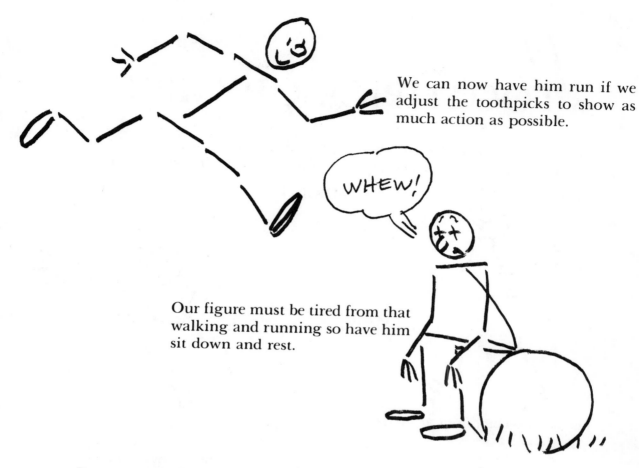

We can now have him run if we adjust the toothpicks to show as much action as possible.

Our figure must be tired from that walking and running so have him sit down and rest.

Rest your own bones for a moment and review what we have done so far. But please don't rest your toothpicks. Rearrange them in all those four positions. Then try drawing the positions without the tooth-picks.

"Would you please tell her I just stopped by?"

14
TOOTHPICK OLYMPICS

AN excellent place to observe the human figure in action is in the world of sports. Let's create some athletic events with our toothpicks.

BOXING

The champ comes out at the bell.

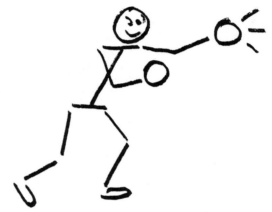

He throws a punch.

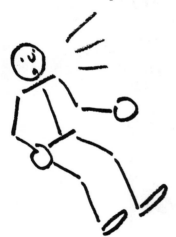

And takes a punch in return.

He's down for the count! *eight, nine, ten, you're out!*

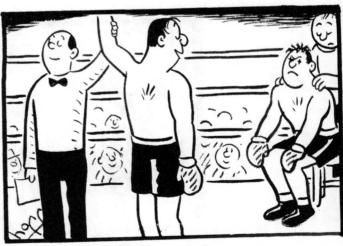

"Now, don't go away angry."

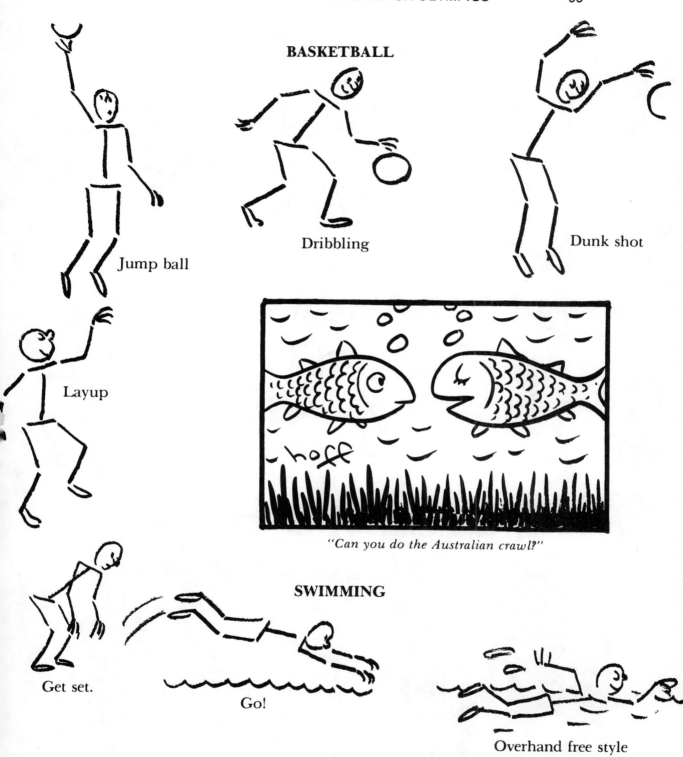

BASKETBALL

Jump ball

Dribbling

Dunk shot

Layup

"Can you do the Australian crawl?"

SWIMMING

Get set.

Go!

Overhand free style

Backstroke

TRACK AND FIELD

Shot put

Pole vault

Discus throw

Relay

BOWLING

Correct grip

On the way to a strike.

Missed!

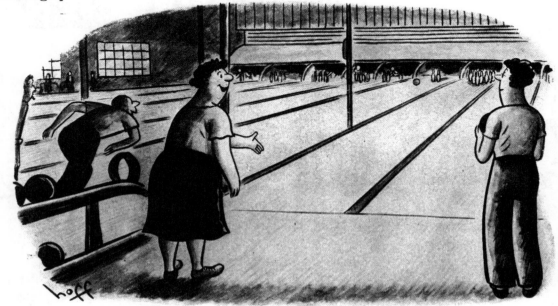

"I'm getting better. I can keep it in the alley almost all the time now."

GOLF

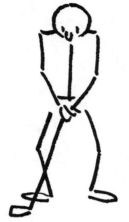

Addressing the ball

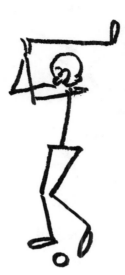

Backswing

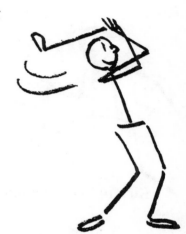

Follow through

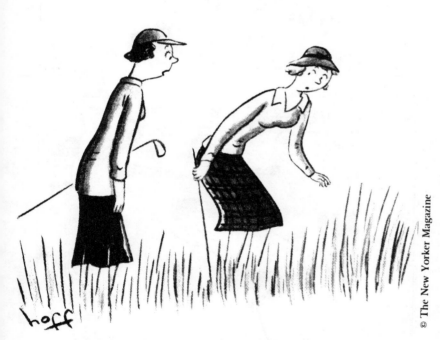

"I'd enjoy golf a lot more if I could get over being afraid of snakes."

hoff

Hole-in-one!

SOCCER

Trapping the ball　　　　　Protecting it

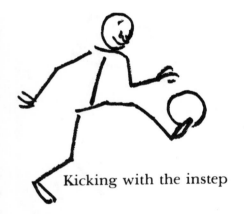

Kicking with the instep

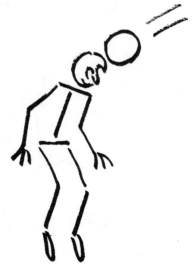

A header

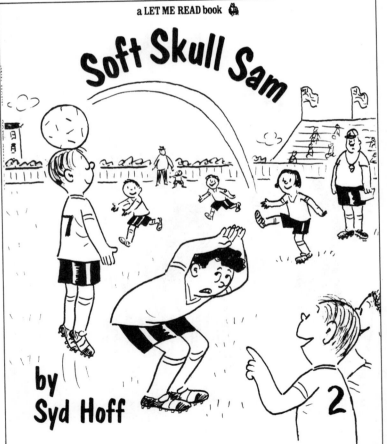

The hero of my book, *Soft Skull Sam*, protects himself from a header.

FOOTBALL

Quarterback

Fading back

A long pass

Tackle attempt Touchdown

Field-goal kick

"And now a few words of praise for myself."

TENNIS

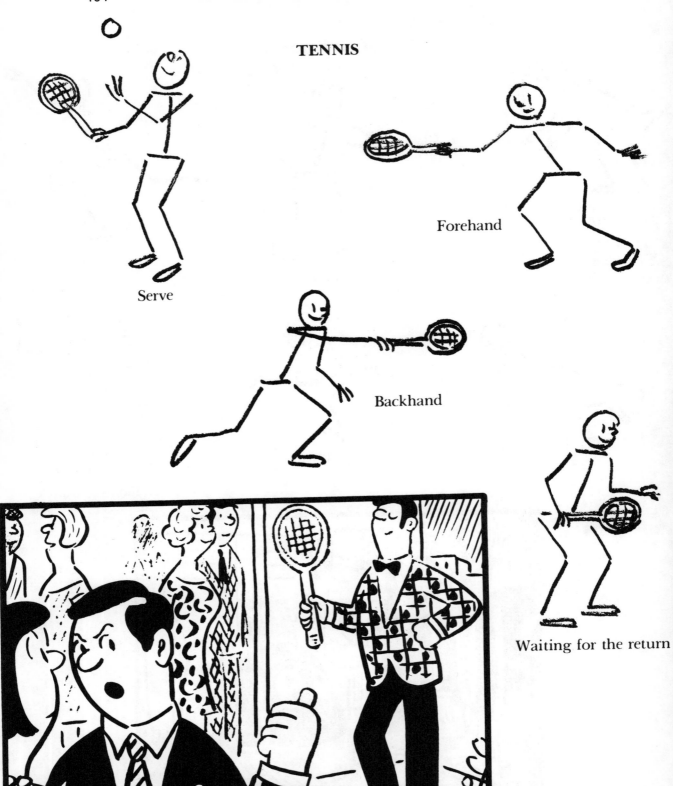

Serve

Forehand

Backhand

Waiting for the return

"Why can't he let us forget he once won the club tournament?"

My favorite sport for studying the human figure in action is baseball.

BASEBALL

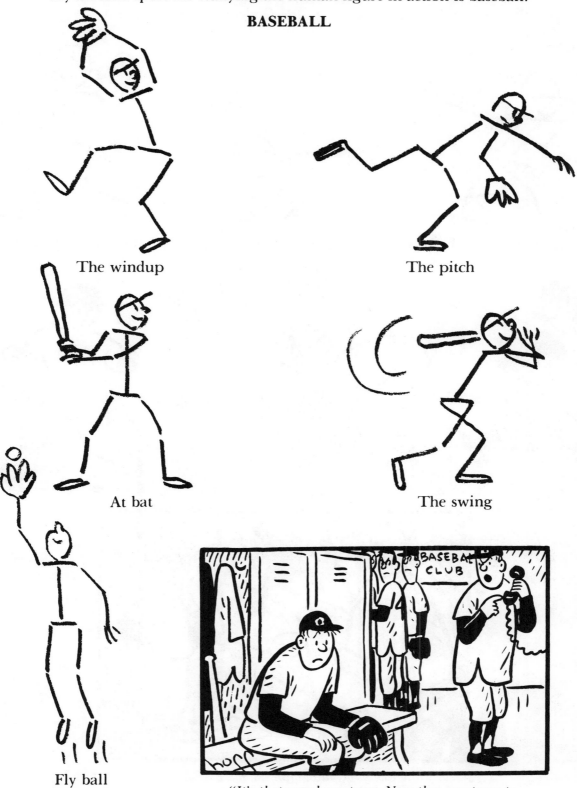

The windup

The pitch

At bat

The swing

Fly ball

"It's that cereal company. Now they want you to say you DON'T use their product."

These are toothpick figures, rough sketches, and finished cartoons for the book, *Play Ball With Roger the Dodger,* by Al Campanis.

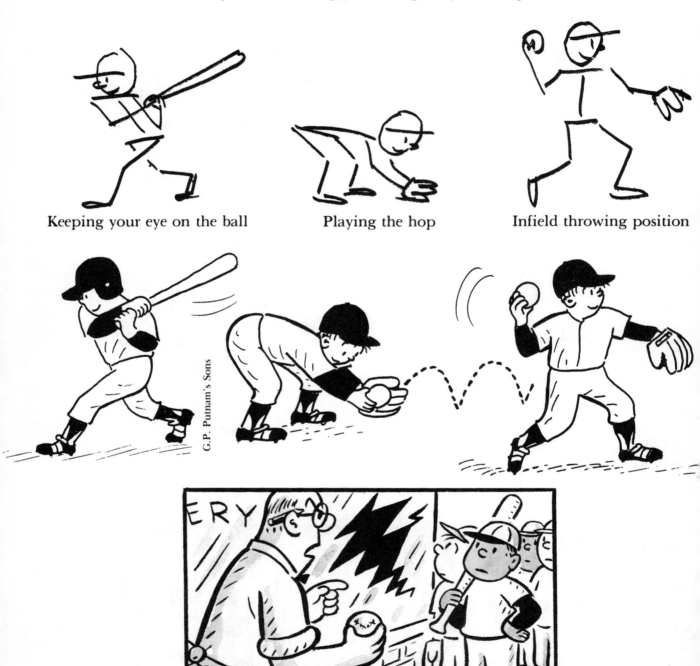

Keeping your eye on the ball Playing the hop Infield throwing position

G.P. Putnam's Sons

"I'd like your autograph on the ball and your father's on a check."

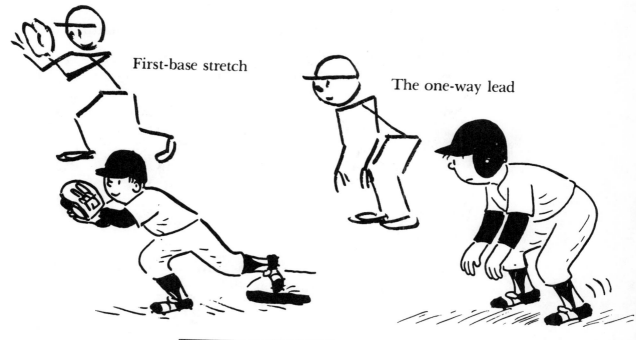

First-base stretch

The one-way lead

Babe Ruth, a boyhood idol of mine, inspired my deep-rooted love of baseball.

Scholastic Book Services

Here is the Babe, in sketches and finished cartoons, starting his professional career in 1917 as a left-handed pitcher.

Here he is after hitting one of his 714 home runs—a record that stood for 40 years until Hank Aaron broke it in 1974.

Later on in his career, Babe Ruth was far from a toothpick figure.

In this cartoon illustration, the Babe's manager orders him to lose weight.

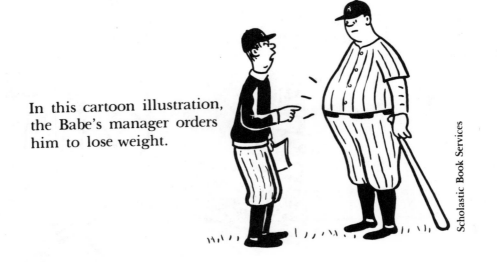

Babe Ruth provides us with more action studies as he goes to a gym instead of restaurants.

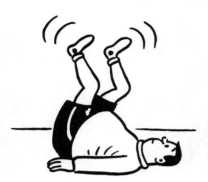 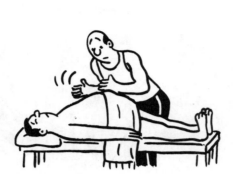 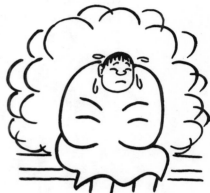

He exercises. He takes rubdowns. He sits in steamrooms.

Babe Ruth lost weight, but for a time he also lost the knack of hitting baseballs. The fans took to booing him. Then they cheered again, as the Babe resumed blasting those homers.

In your mirror study the different actions of athletes, but please be careful of the furniture if you start swinging a broom around the house.

"Forget it—Babe Ruth, Jackie Robinson, Hank Aaron, Willie Mays —they all struck out with bases loaded!"

Action of the human figure is not restricted to sports. It's everywhere. A young explorer is eager to get going as he beseeches the king of Portugal for ships, in *A Book About Columbus* by Ruth Belov Gross. (He later got the ships from the queen of Spain.)

Here, his crew demonstrates action—

—as it wearily performs necessary chores at sea.

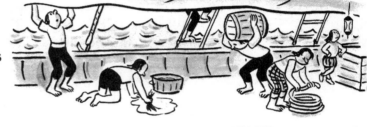

The crew displays another kind of action when land is finally sighted after a month of hopeless despair.

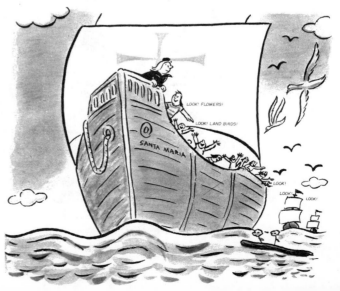

See the action here, as the entire population turns out for the gala homecoming reception, including Columbus' two young sons on the right.

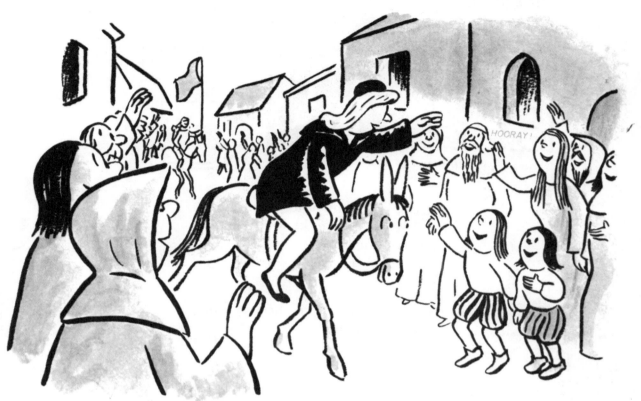

Back to modern times, we find plenty of action displayed by this young man about to take off on an imaginary voyage to a distant star.

"Which planet did you say?"

"Don't worry, he's not trying to come between us."

There is action of a more hesitant sort on the part of this elderly man, who just hopes to make it to a seat on the bench.

"You fellows mind giving us a hand out here?"

The policemen show plenty of action in this cartoon, even though they could use a little "inside" help.

This is how that officer in the foreground might look as a toothpick figure.

Figures do not have to be moving to show action.

"Sir, do you wish to take those peanut shells along with you, or do you want them delivered?"

Here, a park attendant might be getting ready to pounce on that litterbug.

The scout seems capable of pursuing the girl in this cartoon.

"You want to do a good deed, Chuck, a REAL good deed? Don't help me across the street."

Follow the prisoner with your toothpicks in this rough sketch. This is the way an editor saw the cartoon before deciding to buy it.

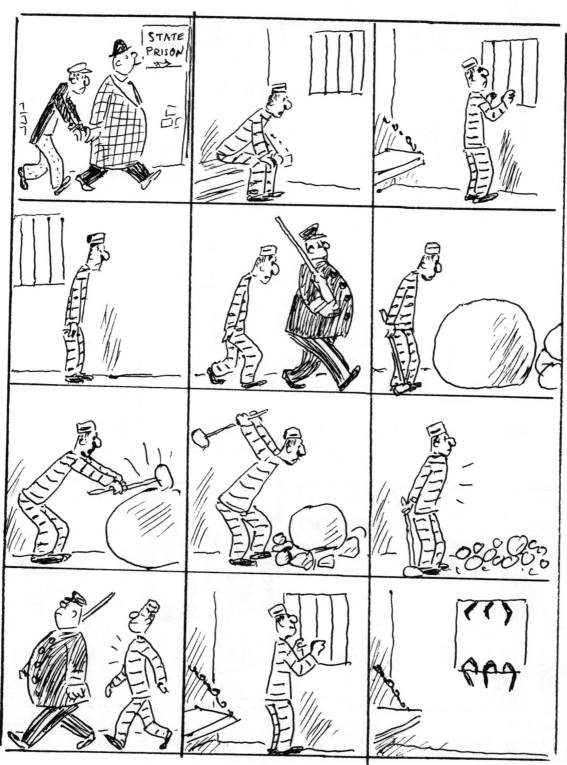

15
BULKS AND HULKS

I T'S time now to put weight on our toothpick figuress. We can do this in four easy steps.

Step 1. Draw our original figure.

Step 2. Add dotted lines.

"Just for old time's sake, how about charging us the same prices as when YOU were a kid?"

"I bet my father used to have a better build than yours used to have."

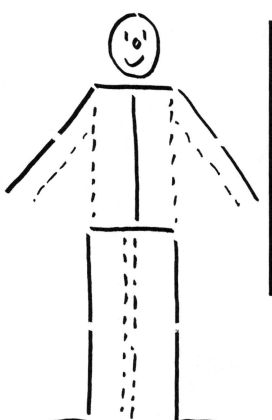

"Do you have one with less air?"

Step 3. Add more dotted lines.

Step 4. Fill in and finish.

"Star Theatrical Agency?"

Put weight on all the toothpick figures we drew on previous pages. Do it on separate sheets of paper so you can see your progress.

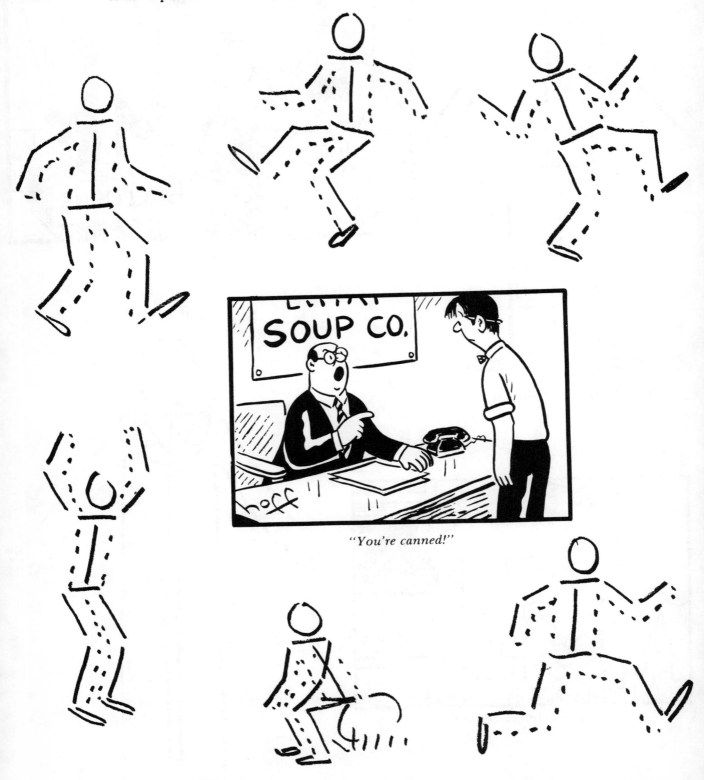

"You're canned!"

Begin shading the figures.

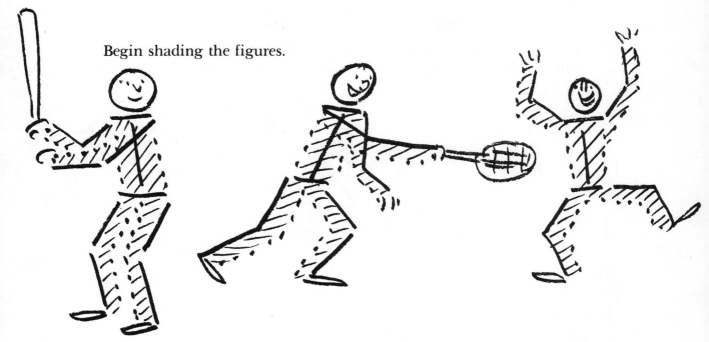

After plenty of practice shading the figures, try drawing them without using dotted lines. When you are satisfied with the results you can omit the dotted lines entirely.

"A penny saved is a penny earned, but what can you buy with it?"

Now try drawing the action you see at school, or in the playground, using as few lines as possible.

Senior citizens move slowly, so you'll need to slow down the movement
of your pen or pencil if you want to draw them.

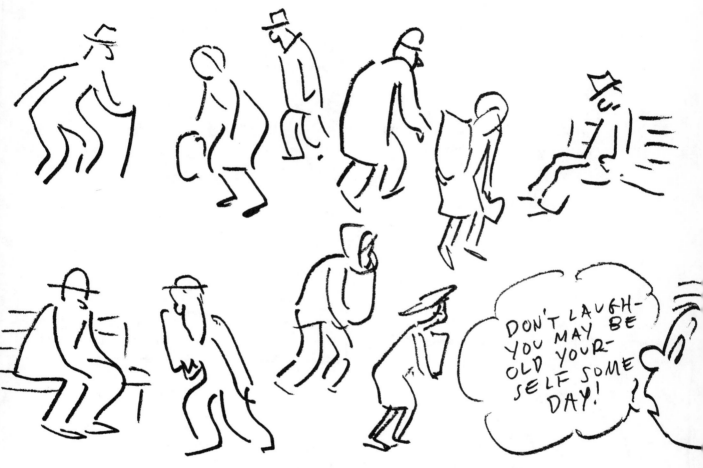

Keep on sketching like this, but don't throw away your toothpicks yet.
We will still be needing them.

"I have a better idea. I'll race you across when the light changes."

Fast loose sketches preceded the cartoon illustrations for the book, *Giants and Other Plays for Kids.*

G.P. Putnam's Sons

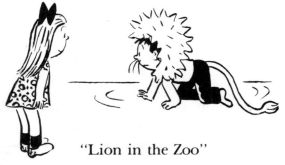

"Lion in the Zoo"

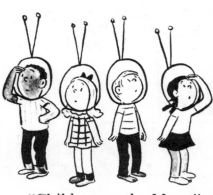

"Children on the Moon"

On the left is the loose sketch for Edward Ricciuti's book, *Donald and the Fish That Walked.* The author, a biologist, first had to describe what this fish actually looks like, and only then did I know how to draw the finished cartoon on the right.

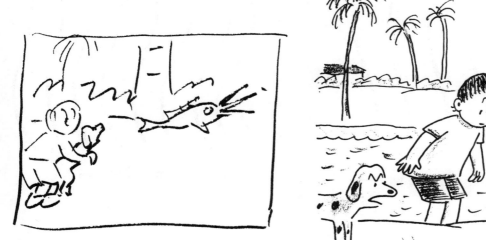
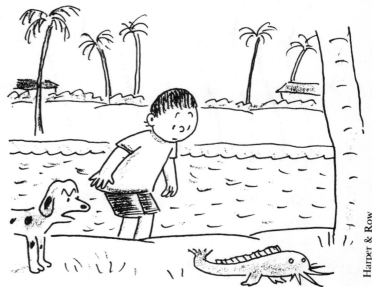

Harper & Row

Another of my "before-and-after" illustrations is the one I did for my own book, *The Witch, the Cat, and the Baseball Bat.*

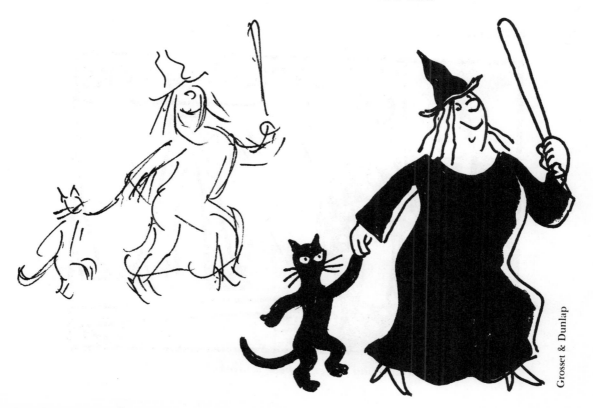

Grosset & Dunlap

The female figure is usually rounder than the male figure. Therefore, it might be a good idea to practice drawing curves.

Draw long curves going this way—

—and that way.

Draw short curves going this way—

—and that way.

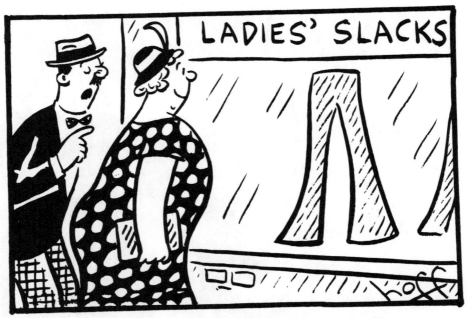

"Wouldn't you prefer to have a mink coat, dear?"

Let's put all the curves we practiced together to make female figures.

Arrange six toothpicks, thus.

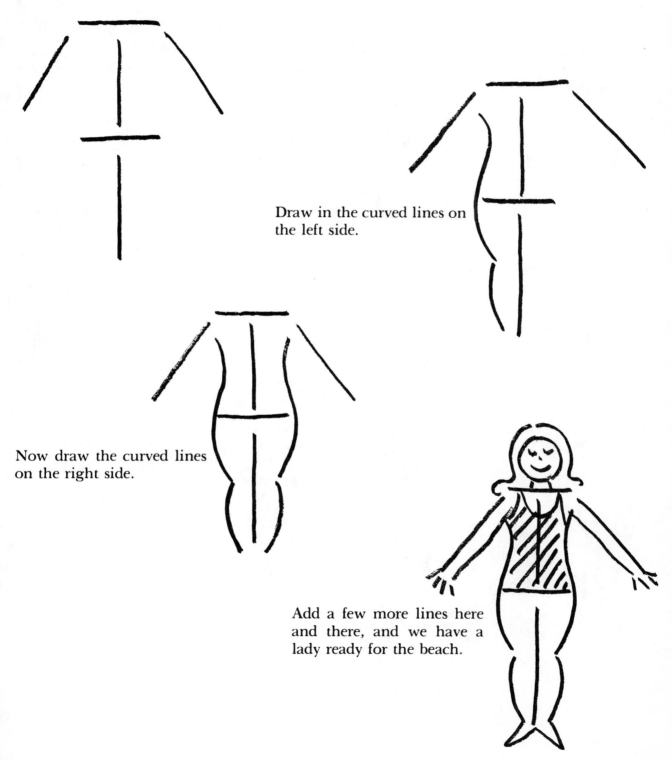

Draw in the curved lines on the left side.

Now draw the curved lines on the right side.

Add a few more lines here and there, and we have a lady ready for the beach.

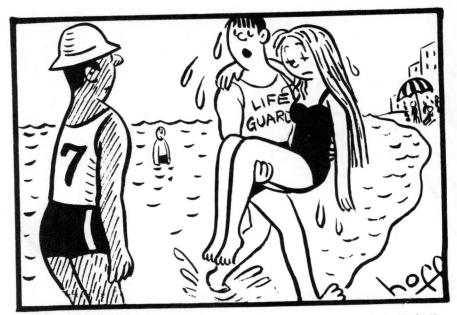

One summer, before I drew this cartoon—

"How should I know who she is? All she's said so far is 'glub-glub'."

—I made these sketches at the seashore.

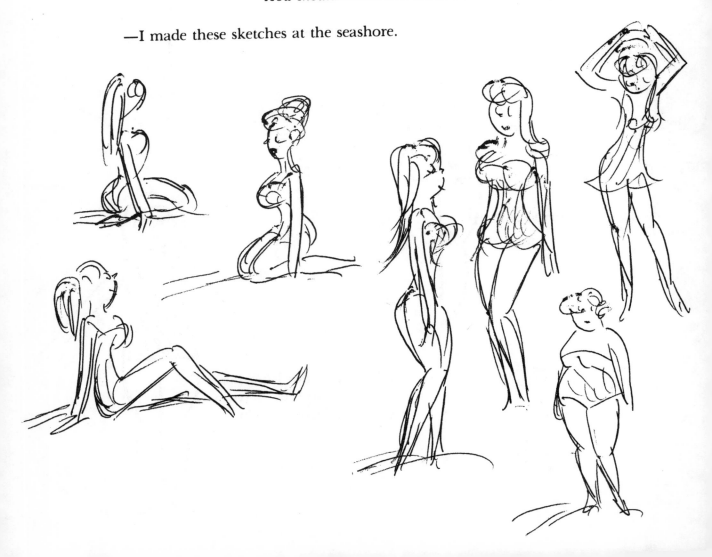

Try to capture the grace of the female figure in as few lines as possible, It will improve the results if you imagine the figures as being cheerleaders, dancers, or skaters.

"It's that ex-ballet dancer."

16
FATS AND SKINNIES

Overweight is a common problem among men and women, so cartoonists have to deal with it. Here's how to draw a fat lady in four steps.

One. Arrange seven toothpicks this way.

Two. Draw in the curved lines on both sides and connect.

Three. Draw in the legs.

Four. Complete the drawing.

"Then I'll expect to see half of you a month from now."

Lest you get the impression that only ladies are fat, I have made drawings showing the evolution of a Little League baseball coach from a pot to a pot belly.

One. Draw a pot with handles

Two. Draw the legs

Three. Draw the head.

Four. Complete the drawing. (Don't forget the whistle.)

"One thing about you—SUCCESS didn't go to your head."

Skinny people, if handled right, can be just as funny in a cartoon as fat people.

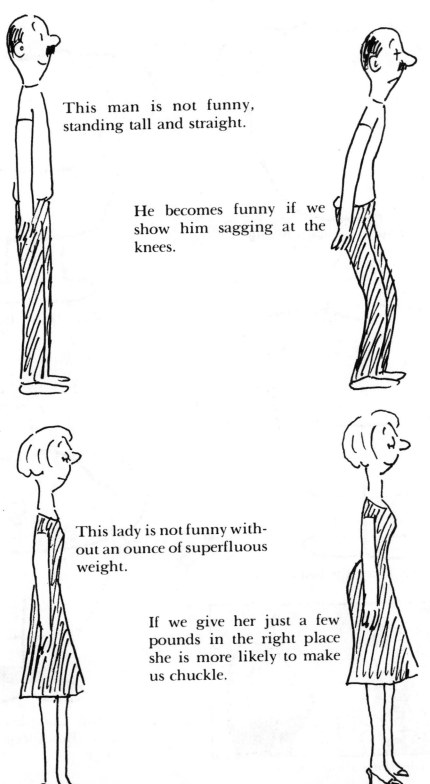

This man is not funny, standing tall and straight.

He becomes funny if we show him sagging at the knees.

This lady is not funny without an ounce of superfluous weight.

If we give her just a few pounds in the right place she is more likely to make us chuckle.

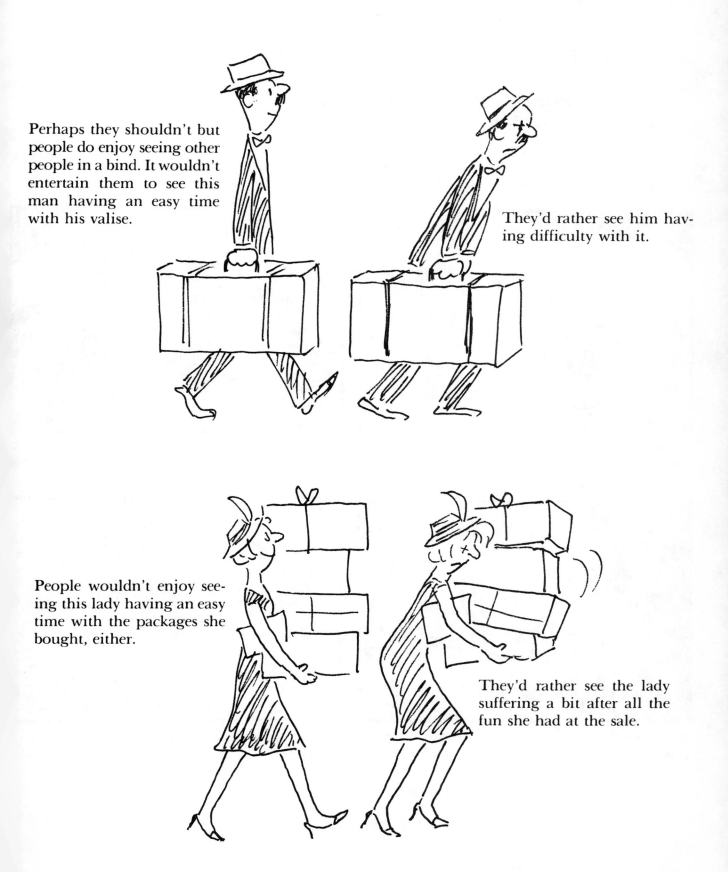

Perhaps they shouldn't but people do enjoy seeing other people in a bind. It wouldn't entertain them to see this man having an easy time with his valise.

They'd rather see him having difficulty with it.

People wouldn't enjoy seeing this lady having an easy time with the packages she bought, either.

They'd rather see the lady suffering a bit after all the fun she had at the sale.

17
TOUCHING ALL BASES

INDOORS or out, fully-clothed or not, no matter what the situation, cartoonists try to draw their subjects as best they can.

"But we do need it to make our cars run, don't we, dear?"

"Well, well, look what the tide washed in!"

"If I have a heart of stone, perhaps it's the age we're living in."

"Go ahead and laugh, but this water pollution is a menace."

"Sir, are these our territorial waters, or must I throw her back?"

Museums are good places to study figure drawings. Statues make the best models because their lines are sharper and their shadows clearer.

It's a good idea to start with busts, or heads. They're easier to draw than full figures.

Of course, you might object that you only want to be a cartoonist, but "art imitates life," as the old saying goes, and the more you know about art the more lifelike your cartoons will be.

"All men are created equally funny," claim cartoonists, offering their own version of that famous passage from "The Declaration of Independence." They mean that everybody is fair game when it comes to laughs.

People of your race

People of other races

People born in your country

People born in other countries

People from here

People from there

People from everywhere

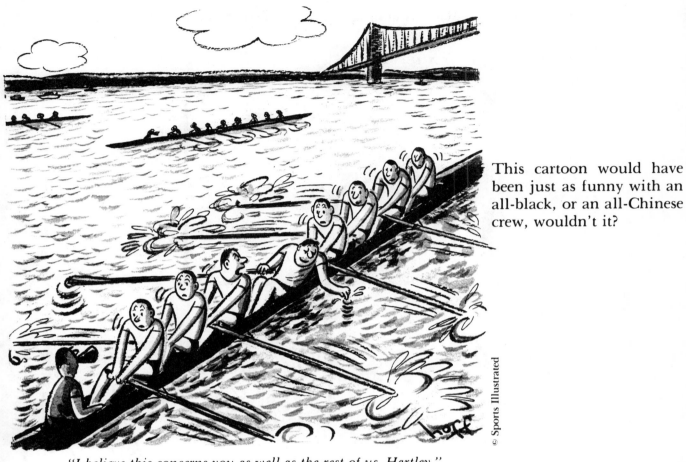

This cartoon would have been just as funny with an all-black, or an all-Chinese crew, wouldn't it?

© Sports Illustrated

"I believe this concerns you as well as the rest of us, Hartley."

Nothing would have been lost if I had made this a Greek or an Italian restaurant.

"Please play something sad. I can't pay the check."

A cartoonist finds laughs among all of Earth's inhabitants.

He finds it in the frozen North—

"Someday all this will be yours, if it doesn't melt first."

—in the lush tropics—

"I hate those fellows. There's no privacy with them around."

—and in his home.

"Junior, say hello to your sponsor."

Subjects for laughs are everywhere—

—atop a Himalayan mountain—

"You're beautiful—in an abominable sort of way."

—or in the deepest forest.

"They're playing our song."

To a caroonist these could have been Laplanders or New Zealand Maoris disembarking in the fjords of Norway, or somewhere along the Amazon.

"Now don't tell me what country we're in. Let me guess."

Children's books afford cartoonists the opportunity to show that the milk of human kindness, as well as India ink, flows in their veins.

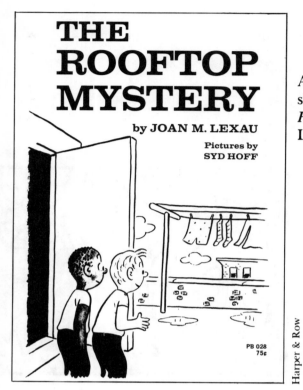

A black boy and a white boy share an experience in *The Rooftop Mystery* by Joan Lexau

Harper & Row

A little girl believes that magic can help solve her problems in the book, *Wandas' Wand*

The C.R. Gibson Company

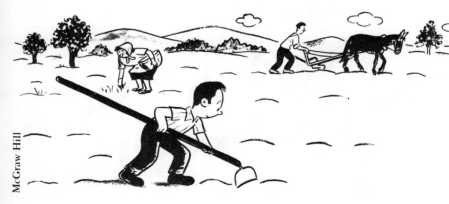

A young Chicano boy helps his parents make ends meet in *Roberto and the Bull.*

McGraw Hill

Another Chicano boy faces a similar problem in *Pedro and the Bananas.*

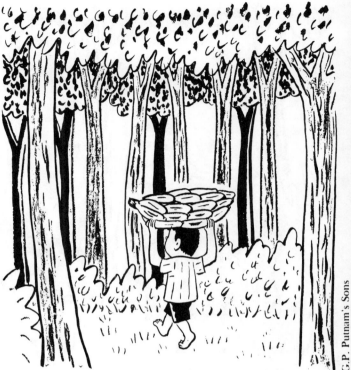

G.P. Putnam's Sons

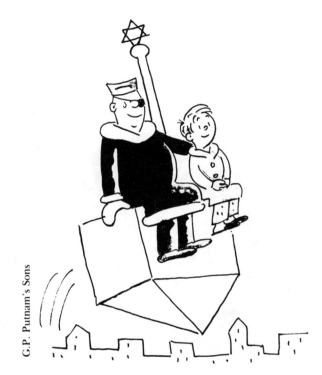

G.P. Putnam's Sons

A Jewish boy goes for a midnight ride with a mysterious stranger in *A Chanukah Fable for Chirstmas* by Jerome Coopersmith.

"I'm walking my dog, and vice versa!"

Harper & Row

Little Chief, an Indian boy, and hero of my book with the same name, suffers the loneliness of a child suddenly left without friends.

Windmill Books and E.P. Dutton

Mary Lou urges Harold not to let his size discourage him in my book, *The Littlest Leaguer.*

McGraw Hill

Shyness is Harvey's problem in the book, *A Walk Past Ellen's House.*

In *I Should Have Stayed in Bed* by Joan Lexau, a black boy's day starts out all wrong the moment he awakes.

He finds soggy sugar in his cereal—

—kicks a nickel into a sewer when he tries to pick it up—

—falls down in class when he tries to take his seat—

—and gets sent to the nurse's office. (That's only the beginning of this boy's troubles!)

Harper & Row

Do you aspire to be a writer, as well as a cartoonist? The best writing is *honest* writing. Try telling a story about yourself, or pretend you're some other person (even an animal), and let your imagination do the rest. Best of all—illustrate what you write.

18
IT TAKES ALL KINDS

IT takes all kinds of people to make a world, and a good cartoonist doesn't spare any of them his jokes and jibes. Below are some favorite subjects.

THE RICH AND THE POOR

"Let's not get the large economy size. Let's get the little one we can afford."

THE SICK AND THE WELL

"When did you start taking these catnaps?"

THE GOOD AND THE BAD

"You are going on a long journey."

THE WED AND THE NEWLYWED

"Can you sing a little faster? This is only a one-day stopover on our honeymoon."

But most of all, a cartoonist loves to draw *kids*.

"My father's a liberal, but not with allowances."

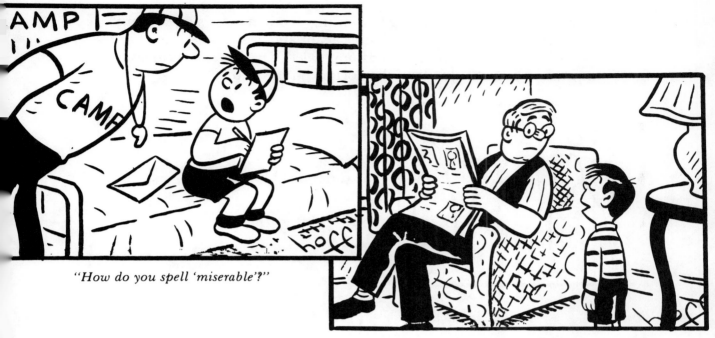

"How do you spell 'miserable'?"

"Grandpa, what was Paul Revere REALLY like?"

"A raise in allowance hardly seems unreasonable, considering all the pleasure you both derive from me."

Spread sunshine all over the place! Be a cartoonist who pokes good-natured fun at everybody.

A cartoonist begins a drawing by blocking it out in large, simple forms, or masses, and if not satisfied, tries again and again until one of the arrangements seems right. For example, let's say the scene is to be an operating room with one of the doctors on the phone.

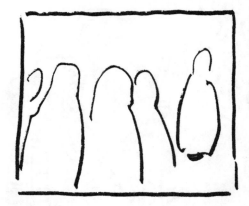

The cartoonist blocks it out in masses, thus.

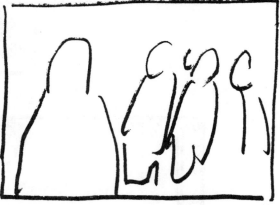

That arrangements doesn't please him, so he tries it another way.

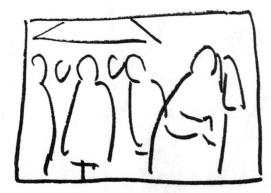

One more stab at a "composition" and the cartoonist is satisfied.

This is the way he finishes the drawing.

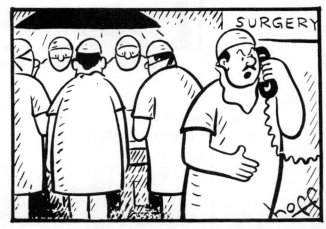

"Well, you've done it again, Myrtle— called me right in the middle of someone!"

The problem in this cartoon was to show two boys at camp engaged in a dispute of epic proportions.

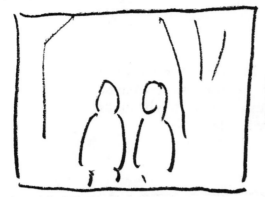

Blocking begins with the two boys centered in the frame.

In now changes with one boy in the foreground calling to the other.

After a few more attempts, the cartoonist settles for this composition.

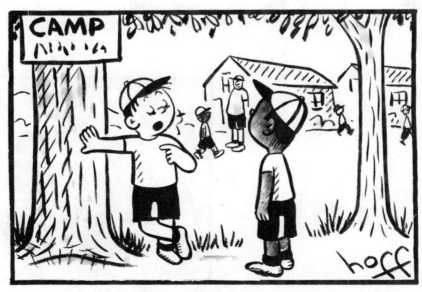

"I bet my parents needed a vacation more than yours."

In the composition on this page I had to deal with two girls faced with a dilemma. They are outside a toy store with neither girl certain of what she wants and I equally unsure of where to position them in the cartoon.

My blocking begins in a blur of confusion (maybe because nobody has brought me a toy lately)—

—with one mass overcrowding another—

—until suddenly I realize that I'm only drawing two little girls—

—and this enables me to complete the drawing as simply as possible.

"Frankly, I don't know what to cry for first."

A happy scene in an office starts out as a problem for the cartoonist trying to get it down on paper. It involves a couple of firemen rushing off to answer an alarm.

The cartoonist tries his masses this way and that—

—then perhaps sensing that a blaze may be getting out of hand if he doesn't hurry, he quickly gets the firemen settled.

"We're invited to a housewarming!"

Try using "masses" when you plan a cartoon, moving them around until one arrangement or composition seems better than the others.

19
HOW TO MAKE UP JOKES

Sometimes, in spite of a cartoonist's experience, the "well runs dry" and new ideas are slow in coming.

He studies the bottle of ink—

—and sees a face.

He heats up the kettle—

—and sees another face.

He takes a piece of fruit—

—and sees something else.

Grosset & Dunlap

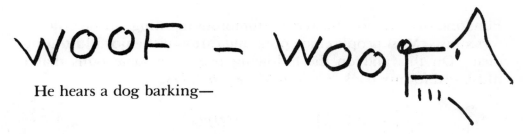

He hears a dog barking—

—and sees him.

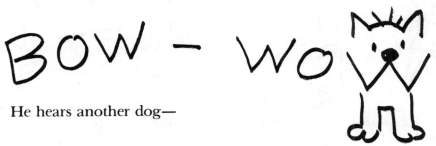

He hears another dog—

—and sees him too.

The cartoonist begins to feel that he's going to the dogs.

Then at last he gets an idea for a cartoon, a terrific idea—

"Why should I learn how to cook? I expect to marry a rich man and eat out every night."

—but remembers he used that idea ten years ago! Our cartoonist puts out the light and goes to sleep, confident that this slump will pass, as did all the other slumps he's ever had.

Puns and plays on words to create humorous meanings are favorites of cartoonists. Most people enjoy puns and cartoonists enjoy illustrating them. On this and on the following pages are some puns that I illustrated for my book, *How to Make Up Jokes*.

"I saw a lady taking a candle into a restaurant."
"Perhaps she was having a light lunch."

"Deer are always jumping around the forest."
"Some fawn!"

"My father got wet on the golf course when it rained, but I didn't."
"You must have been under par."

"The cheese is all gone."
"That's mice."

"What did that fish in the aquarium say?"
"Long time no sea."

"That horse won't come out of his stable."
"Maybe it's only a stall."

Grosset & Dunlap

Clever puns give people a laugh but don't spend too much time on them. Cartooning requires a higher form of humor.

"Which cows give milk?"
"The udder ones."

"My feet hurt."
"Please don't get corny."

"What does your mother do about her weight?"
"She makes light of it."

"I hear Mr. Smith went into the plumbing business."
"Yes, he took the plunge."

"How many puppies do you have?"
"Poodles of them."

"What do you think of all the money tennis pro's make."
"Aw, they've got a racquet."

Cartoonists get ideas from the most unlikely sources.

"This foreign car of yours is just homesick."

A friend's complaint about the high cost of repairing his imported car gave me this idea.

"I hate the name Murgatroyd. Don't you have any other uncles with ten million dollars?"

A birth announcement in the society columns was responsible for this cartoon.

I would never have thought of this if I hadn't been listening to the weather reports from the Middle West one wintry night.

A lost child suddenly being found after a few hours gave me this idea.

"Lovely weather, Dr. Mahley—just right for the flu."

"We've been gone five minutes. Do you think the FBI has been notified yet?"

This idea presented itself while dining in a Chinese restaurant.

"We have no fortune cookies. However, I'm highly intuitive."

Test yourself. See if you can guess the captions for these cartoons. (My answers are set in small bold face type.)

1. "I think my sore throat is much better."

2. "May I have a refill of last week's prescription?"

3. "I'd like you to look at my left elbow, please."

4. "Are you also a baby doctor?"

5. "Thanks, doctor, I feel like a new Napoleon."

(Answer: 5)

1. "Now may I see the monkeys?"

2. "I want another bag of peanuts."

3. "My yelling at you is not police brutality."

4. "I really wanted to go to a movie, instead of the zoo."

5. "What time do they feed the animals?"

(Answer: 3)

Here are two more cartoons on which to test your skill in selecting the correct captions.

1. "Do you know the story of "The Three Bears?"

2. "Did I ever tell you about my den mother?"

3. "Boy, how I wish I were back in my old forest."

4. "Do you like honey as much as I do?"

5. "Put it away! Here come some more tourists."

 (Answer: 5)

1. "Yes, you may have a vacation the first two weeks in July."

2. "Please send in my secretary."

3. "I'm sure you'll have a promotion coming shortly, Smith."

4. "How can I feel like a success when there's so much money I still want."

5. "We'd like you to be sure to attend our Christmas party."

 (Answer: 4)

Make up your own caption's for these cartoons and match them with mine which are printed lower down on the page.

1. "I'm not afraid of the dark, just what might be out there."

2. "What's wrong with you people? I keep getting the wrong number."

3. "I just want to be able to open jars when my wife asks me to."

4. "Actually, I got the headache listening to their jingle on television."

Are some of your captions similar to mine? Do you like any of yours better?

Whenever you come across a cartoon, cover up the caption and see if you can think of one yourself. It's good practice. Getting ideas will become easier and easier.

20
HOW TO DRAW ANIMALS

ALL kinds of animals appear in cartoons. Here's how to draw some of them.

DOGS

Cartoonists draw every species of "man's best friend."

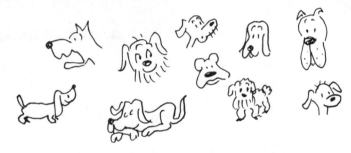

This is a canine face in four steps.

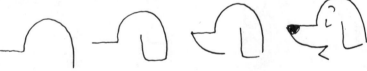

Dogs can walk—

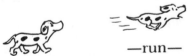

—run— —sit up and beg— —roll over and play dead.

"All those in favor of chasing a cat, say 'ARF'."

"Did you ever run into a girl named Little Red Riding Hood?"

The wolf is a member of the dog family.

CATS

Every cartoonists draws cats differently.

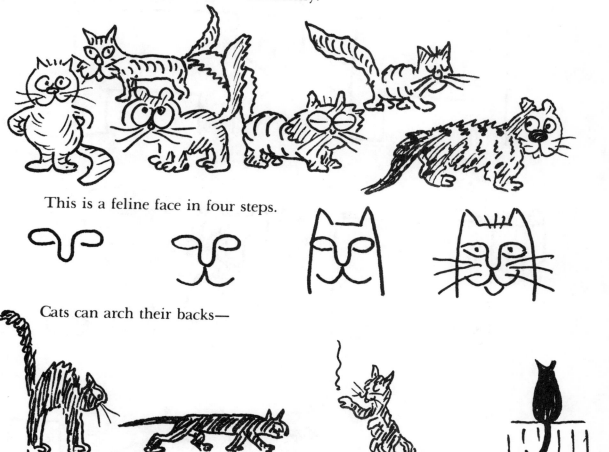

This is a feline face in four steps.

Cats can arch their backs—

—creep stealthily—

—play with a string—

—sit on a fence.

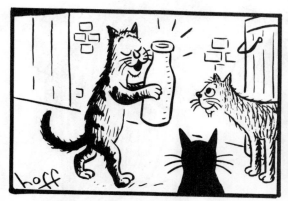

"They call me the Cat Burglar."

"But all you saw was ONE little mouse."

BEARS

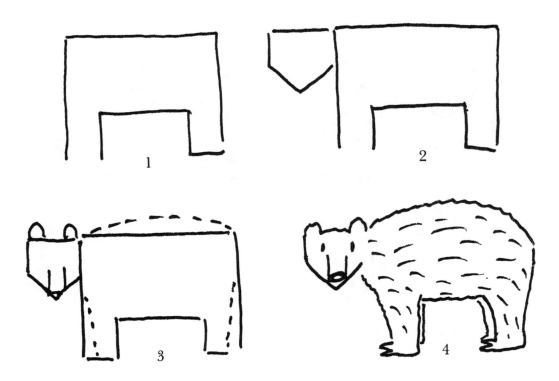

A bear almost gets a ticket for parking in this illustration from my book *Grizzwold*.

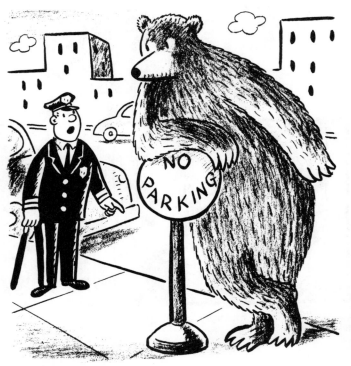

Harper & Row

BIRDS

SQUIRRELS

CAMELS

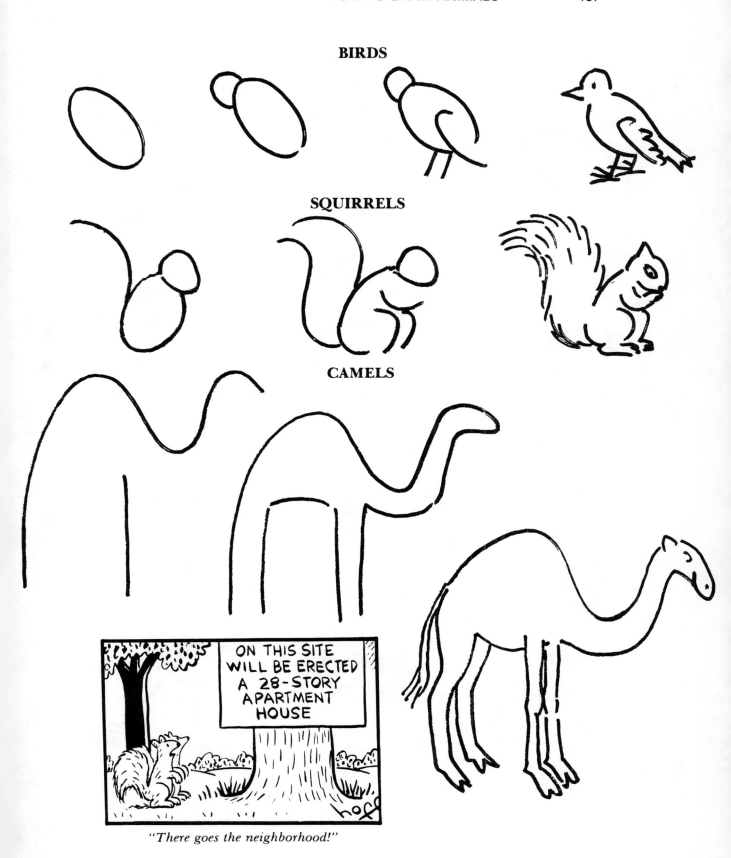

"There goes the neighborhood!"

DUCKS

SEALS

PIGS

TURTLES

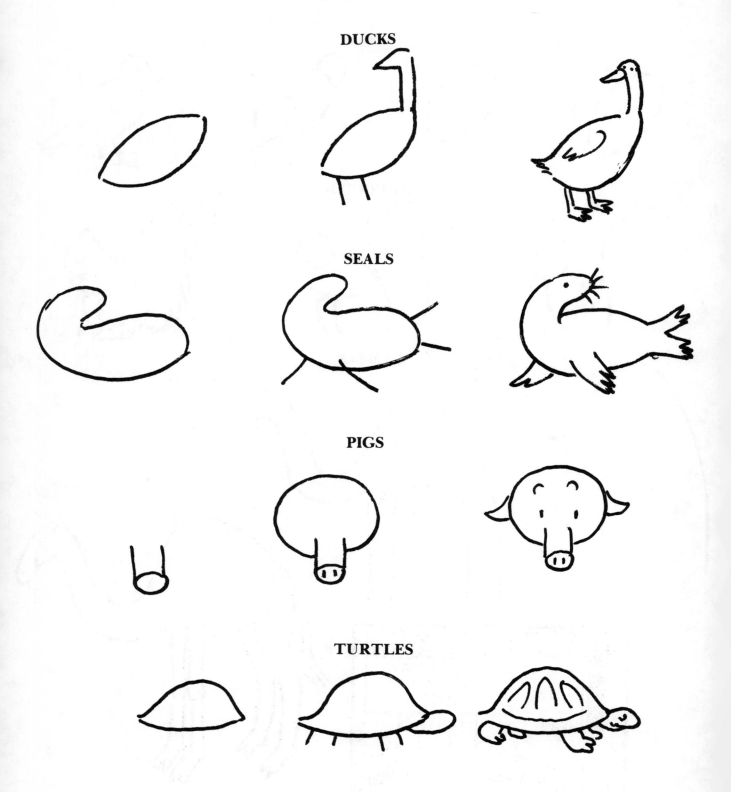

COWS

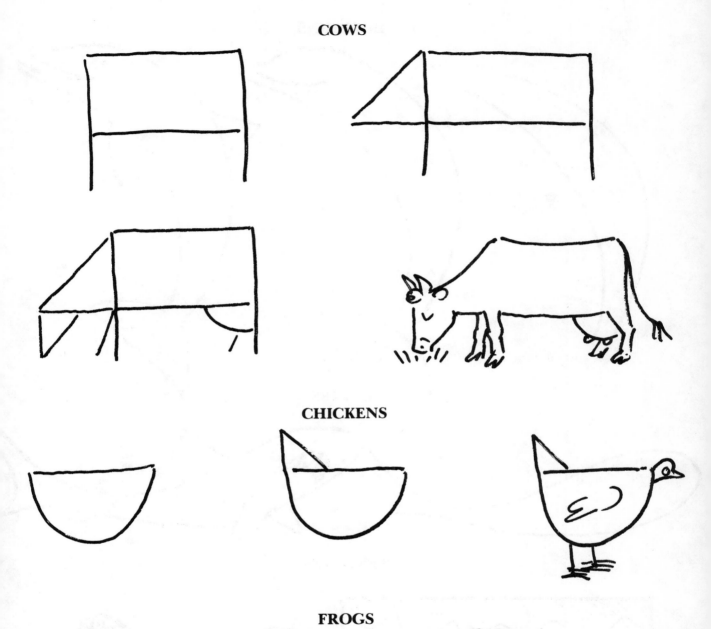

CHICKENS

FROGS

DOLPHINS

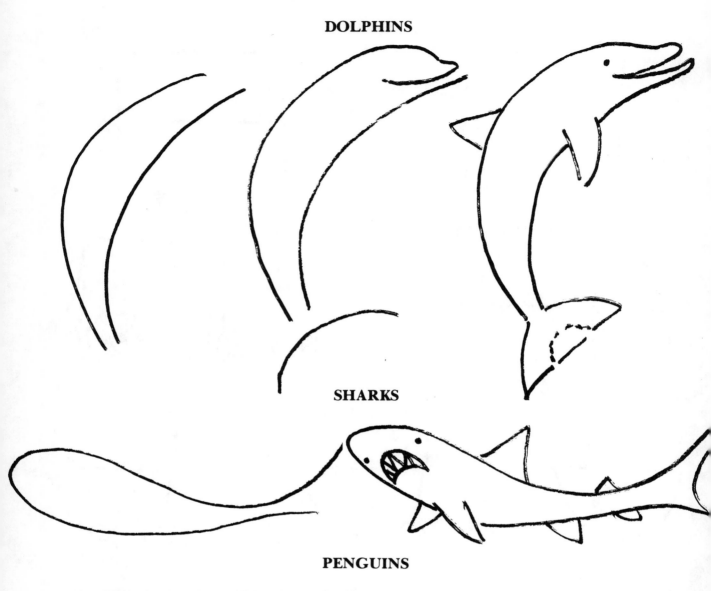

SHARKS

PENGUINS

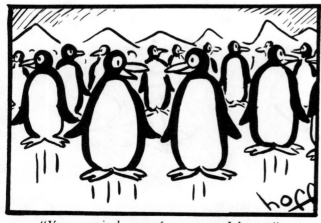

"You remind me of someone I know."

GIRAFFES

SKUNKS

WALRUSES

Walpole, the hero of my book by that name helps young walruses who have lost their mothers.

Harper & Row

HORSES

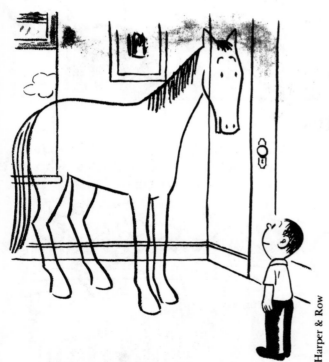

Nobody but Harry could see the horse in my book, *The Horse in Harry's Room.*

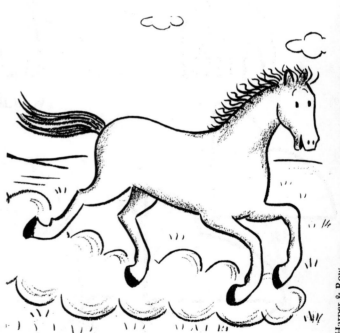

Thunderhoof, the hero of my book by that name, was a horse who just wanted to run free.

MICE

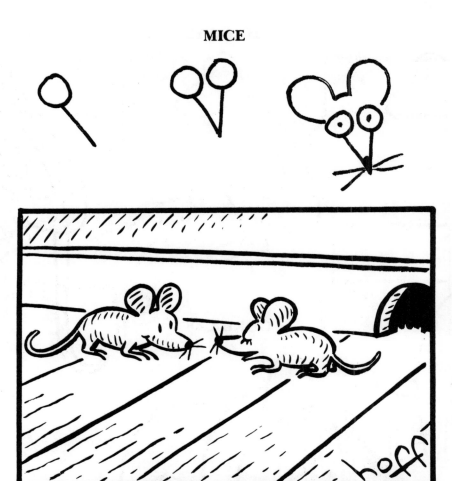

"You'll find some cheese in the kitchen."

YAKS

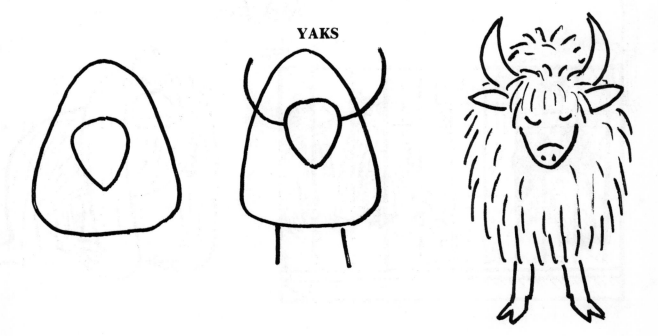

MONKEYS

GORILLAS

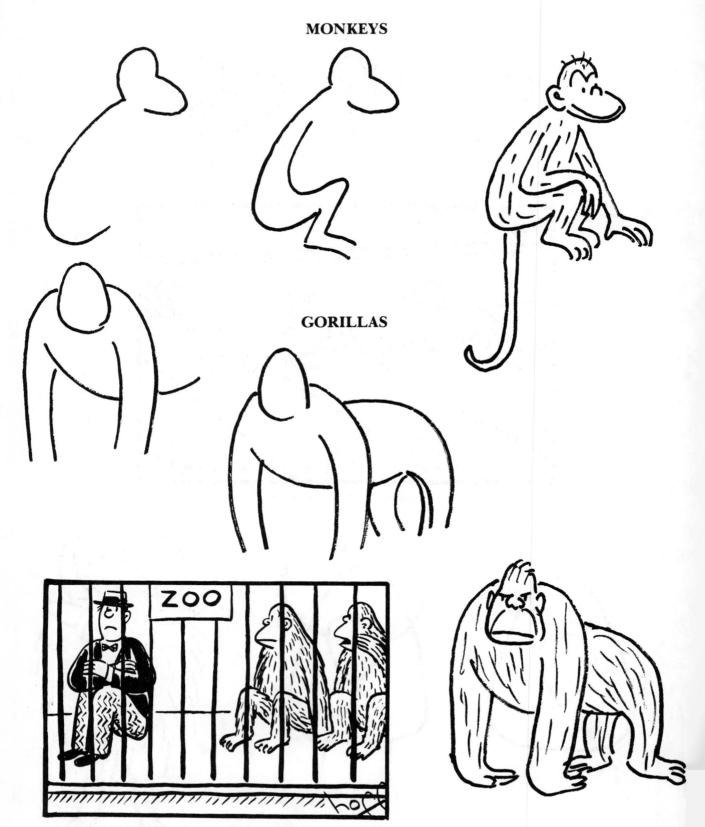

"He's resigned from the human race."

LIONS

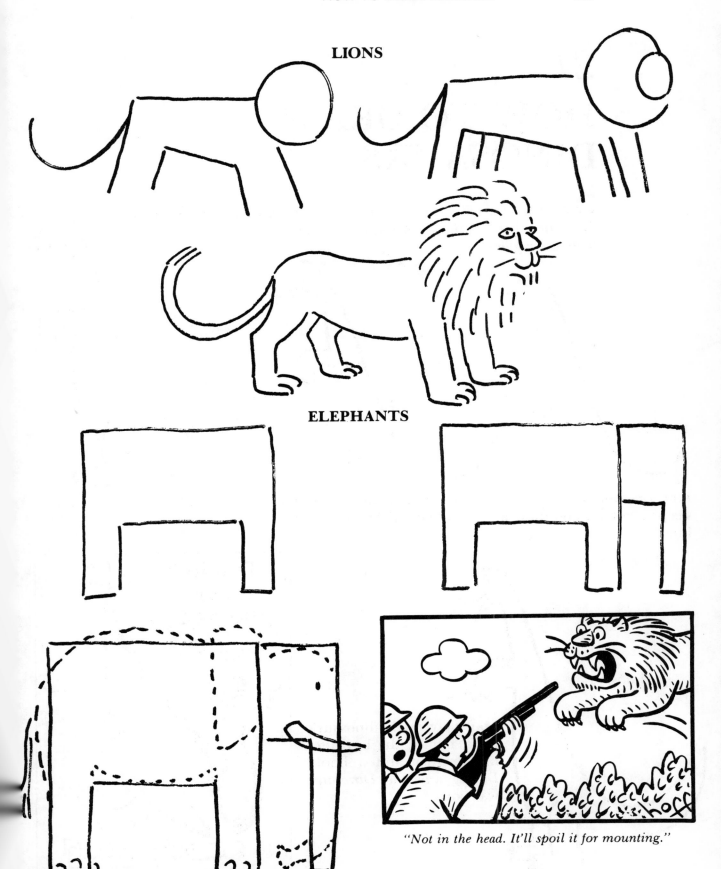

ELEPHANTS

"Not in the head. It'll spoil it for mounting."

21

HOW TO DRAW DINOSAURS

DINOSAURS lived a hundred million years ago, but cartoonists still draw them because they look like exaggerated animals, and cartoonists love to exaggerate.

Late one night I couldn't sleep. I got up and drew a line.

I was drawing an animal, but I didn't know what kind.

Then I realized that it was—

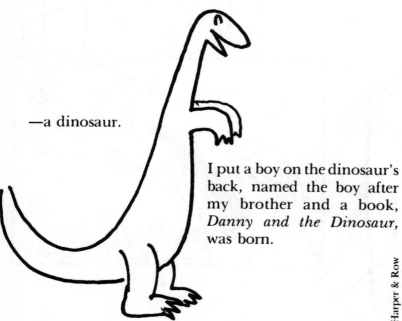

—a dinosaur.

I put a boy on the dinosaur's back, named the boy after my brother and a book, *Danny and the Dinosaur*, was born.

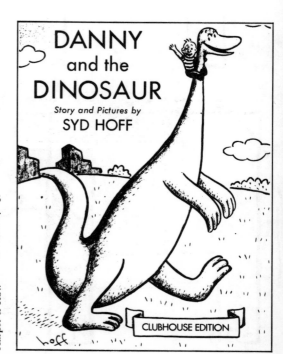

Harper & Row

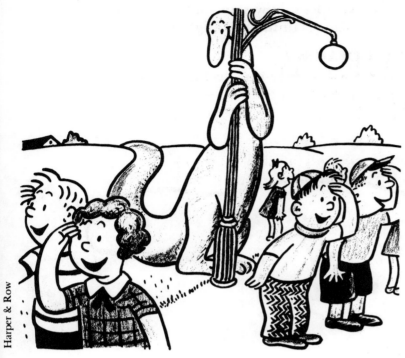

Children pretend they can't see the dinosaur when they play hide and seek.

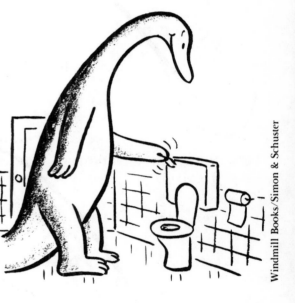

Another dinosaur in the book *Dinosaurs Do's and Don'ts* shows he knows how to flush a toilet.

He also shows he has acquired good manners by wiping his feet before entering a house.

My dinosaurs are make-believe. Now let's draw some of these prehistoric creatures closer to the way scientists think they might have been.

STEGOSAURUS

Stegosaurus (STEG-oh-sawr-us) was twenty-nine feet in length and might have gone around picking on other animals—

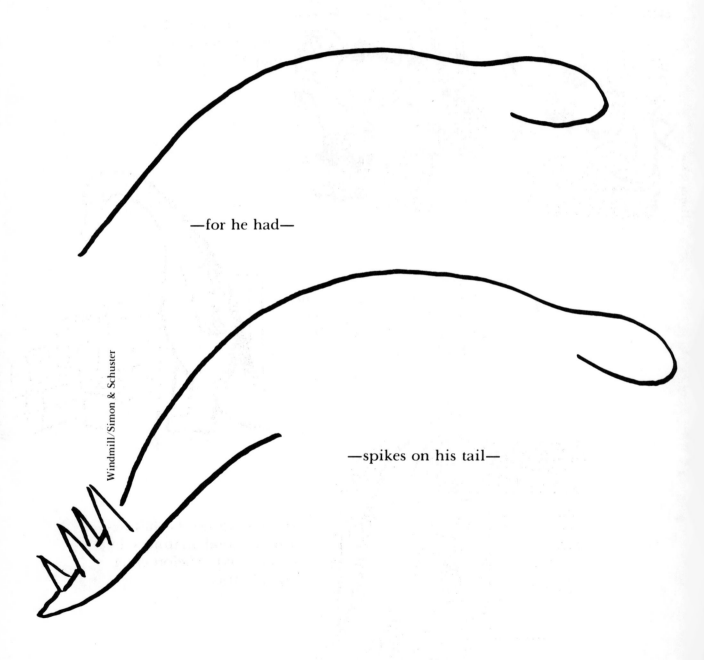

—for he had—

Windmill/Simon & Schuster

—spikes on his tail—

—and hard, bony plates on his back—

—but he much preferred just to pick on plants.

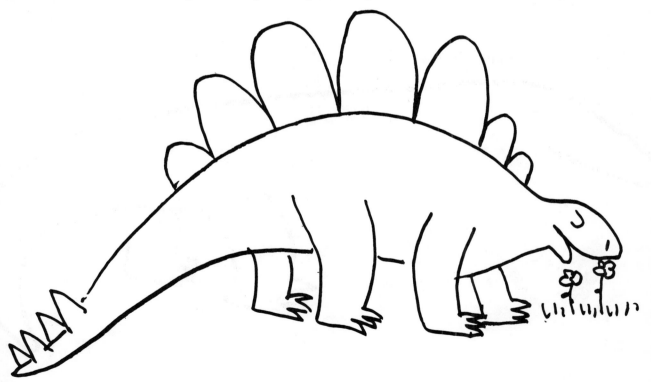

DIMETRODON

Dimetrodon (die-MEET-roe-don), who could eat meat and vege-
tation—

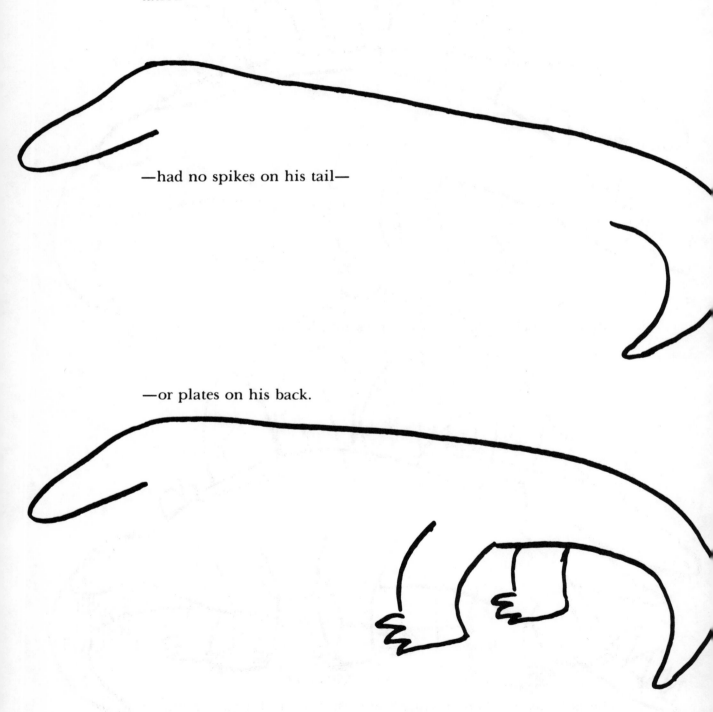

—had no spikes on his tail—

—or plates on his back.

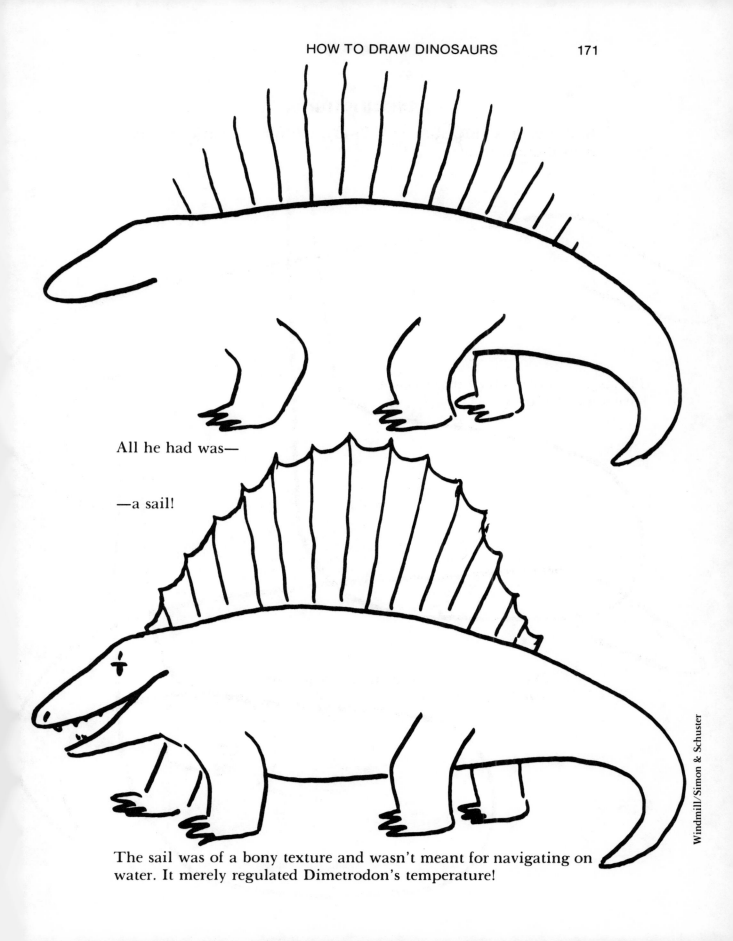

All he had was—

—a sail!

The sail was of a bony texture and wasn't meant for navigating on water. It merely regulated Dimetrodon's temperature!

BRACHIOSAURUS

Brachiosaurus (BRAK-ee-oh-sawr-us), at fifty tons, was even larger than Brontosaurus.

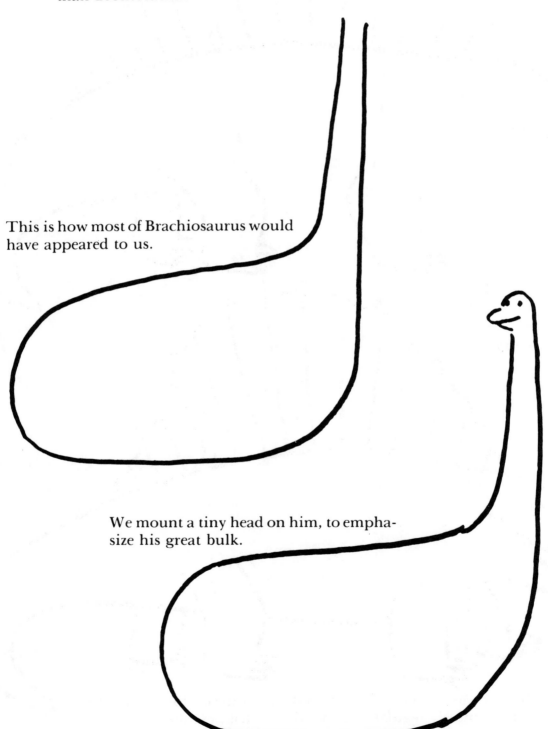

This is how most of Brachiosaurus would have appeared to us.

We mount a tiny head on him, to emphasize his great bulk.

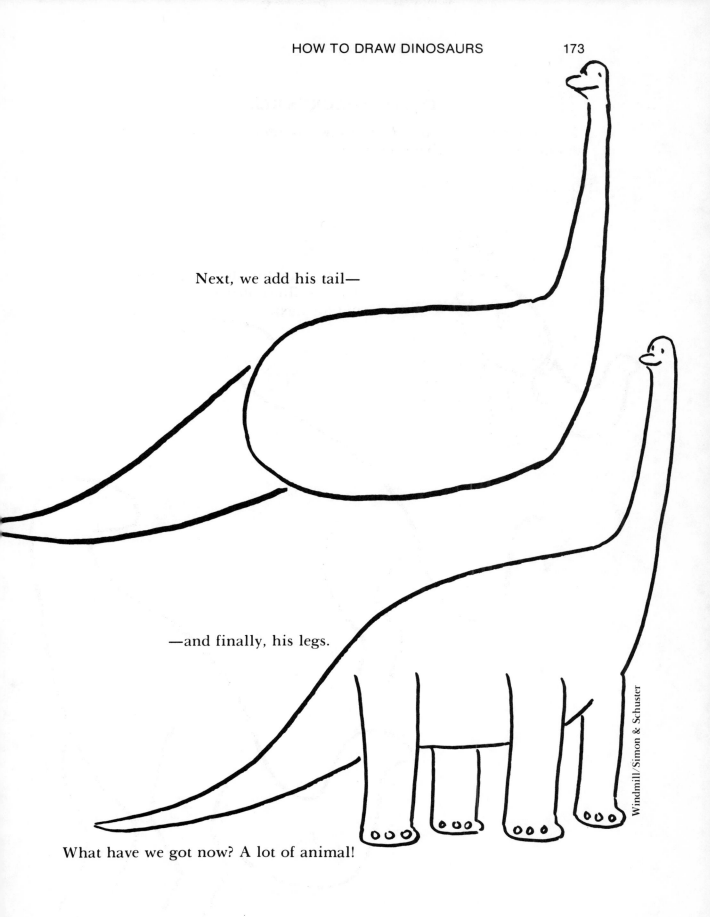

Next, we add his tail—

—and finally, his legs.

What have we got now? A lot of animal!

Windmill/Simon & Schuster

TYRANNOSAURUS REX

Tyrannosaurus Rex (tie-RAN-o-sawr-us rex) was ten tons of the mightiest dinosaur that ever lived.

Diagram for this dinosaur:

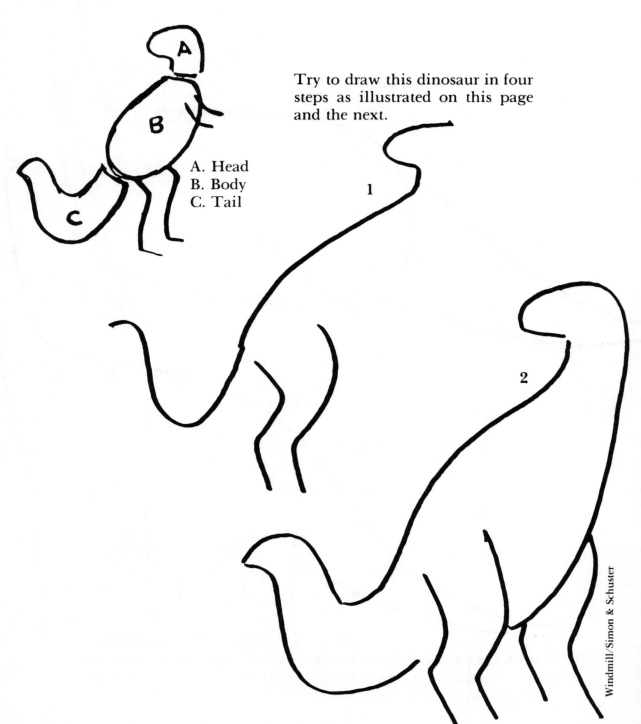

A. Head
B. Body
C. Tail

Try to draw this dinosaur in four steps as illustrated on this page and the next.

Windmill/Simon & Schuster

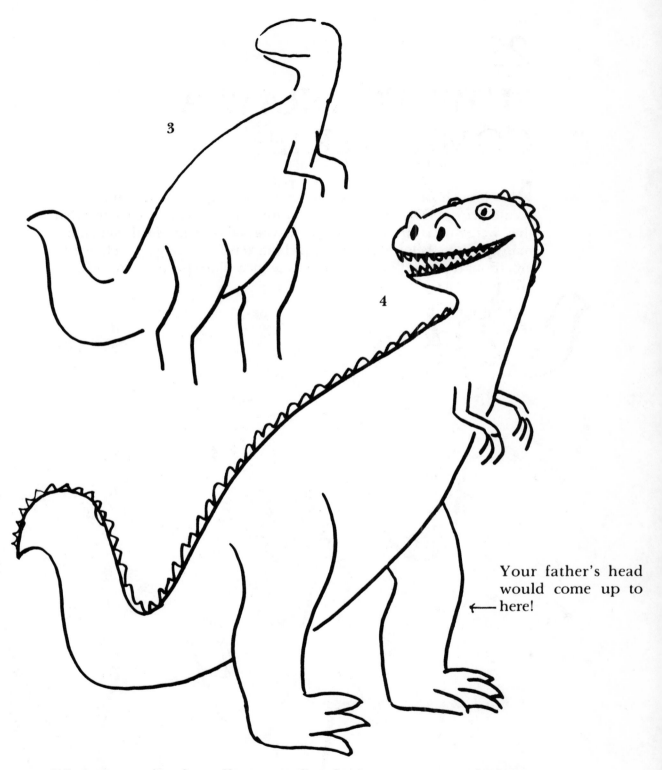

Your father's head would come up to ← here!

When cartoonists draw dinosaurs, they don't worry too much about realism. They just want to be amusing, the same way as when they draw everything else. So, study these prehistoric creatures, then put down on paper your *impression* of them.

22
HOW TO DRAW A COMIC STRIP

No branch of cartooning excites the young cartoonist more than comic strips. I used to copy the old comic strips often. I'd get to feel that they were my creations too. Copying is good practice. I still remember many of those beloved comic-strip characters from long ago. Here they are, though some, I'm sorry to say, are mere shadows in my mind after all these years.

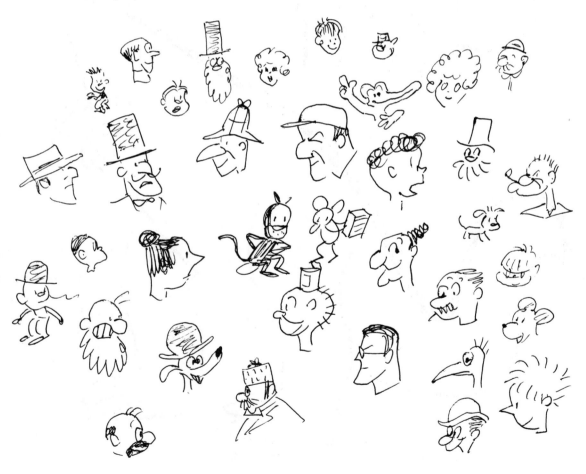

Perhaps your parents or grandparents will recognize these comic characters from the "funnies." You, though, can study them and perhaps they will inspire you to create a comic-strip character of your own. In the meanwhile, continue to copy your favorite comic strips that appear in today's newspapers. It's great fun. (Confidentially, I'm still doing it.)

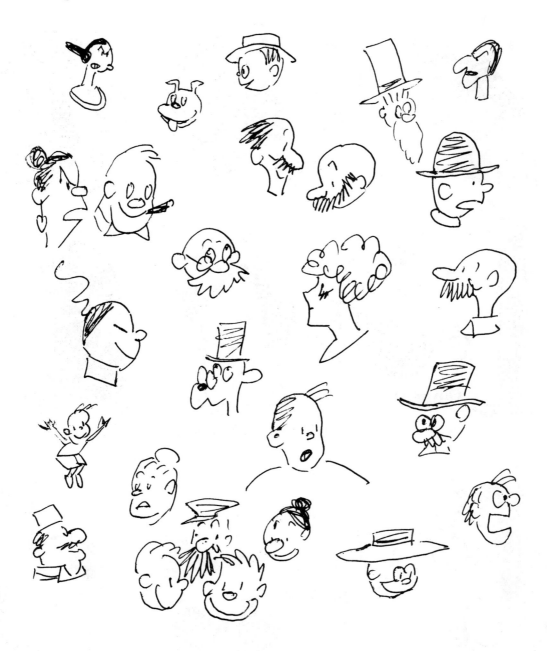

Here are some comic-strip characters that will never be forgotten. Popeye, the lantern-jawed old salt of Elizar Segar's "Thimble Theatre," has endured in newspapers and films since 1921 when the cartoonist happened to introduce him in a sequence that required someone of his description. Popeye's supporting cast, also shown here, is just about as famous as the star himself.

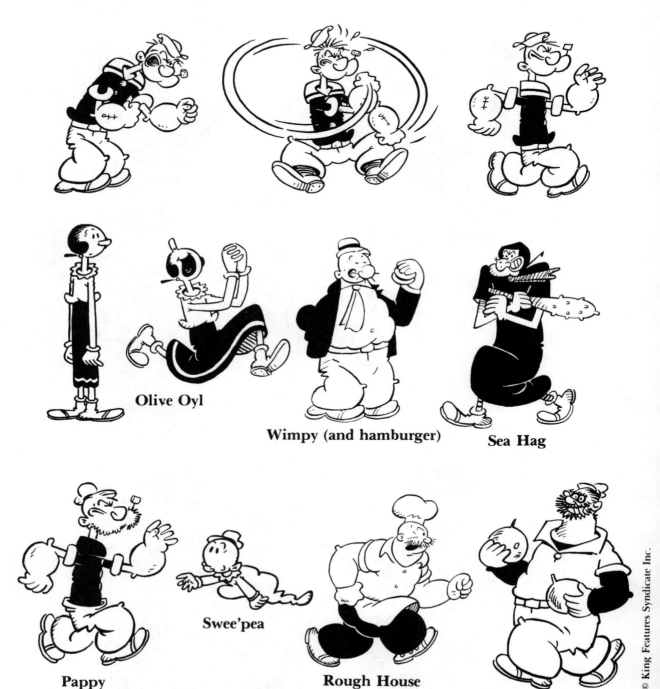

Olive Oyl

Wimpy (and hamburger)

Sea Hag

Pappy

Swee'pea

Rough House

Brutus

"The Katzenjammer Kids," featuring those irrepressible mischief-makers, Hans and Fritz, was begun before the turn of the century, by Rudolph Dirks. The German accent is due to the fact that Dirks fashioned his characters after those appearing in another strip, "Max und Moritz," by Wilhelm Busch, which had already achieved great popularity abroad.

"Bringing up Father", was created by George McManus and featured one of the world's fightingest married couples—socially ambitious Maggie and her cigar-smoking husband, Jiggs, an ex-bricklayer who had struck it rich in the Irish sweepstakes but refused to change his life style to fit his new wealth.

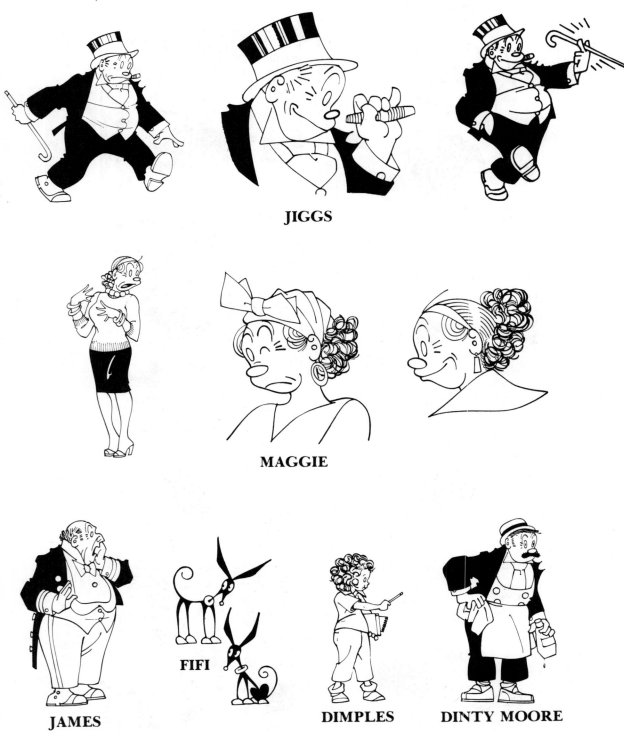

JIGGS

MAGGIE

JAMES FIFI DIMPLES DINTY MOORE

"Krazy Kat" is universally regarded as having achieved the finest art and literary quality of any comic strip in history. George Herriman's cartoon began before World War I and for decades told the story of Kokonino County, where a playful mouse named Ignatz tossed bricks at Krazy Kat under the not-so-watchful eyes of a dog, called Offisa Pup.

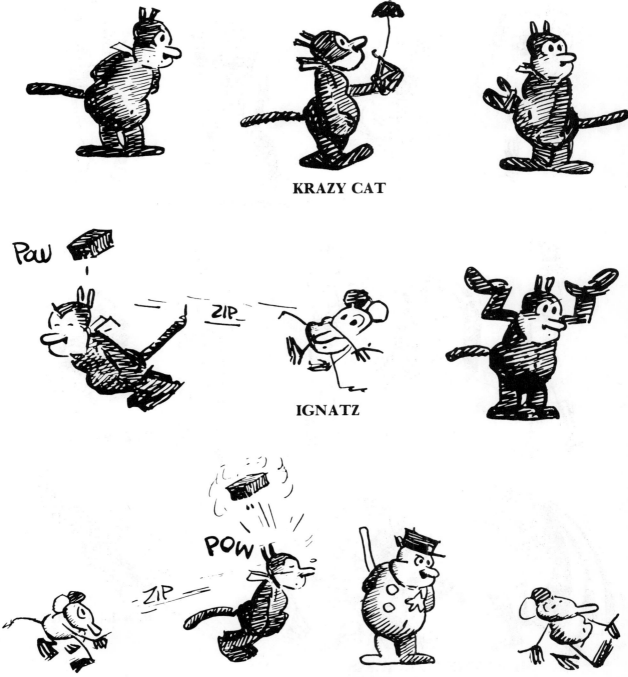

KRAZY CAT

IGNATZ

OFFISA PUP

"Flash Gordon," a pioneer science-fiction adventure strip combining reality and fantasy, was created by illustrator Alex Raymond. His figure drawings, unlike the story line, avoided exaggeration and required the talent of an accomplished artist.

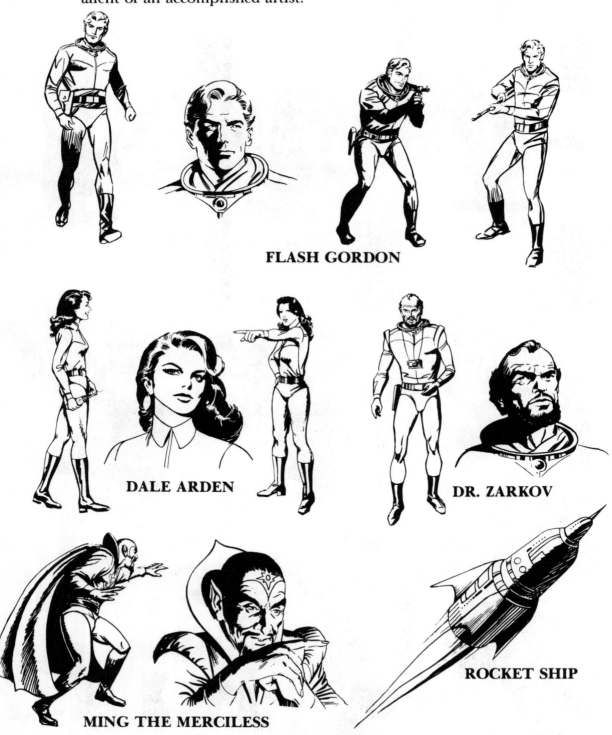

FLASH GORDON

DALE ARDEN

DR. ZARKOV

MING THE MERCILESS

ROCKET SHIP

"Polly and Her Pals" remains one of the great comic strips of all time. In this Sunday newspaper page, from 1937, Polly's dress and shoes may appear dated but not cartoonist Cliff Sterrett's superb graphic art—the latter will never go out of style.

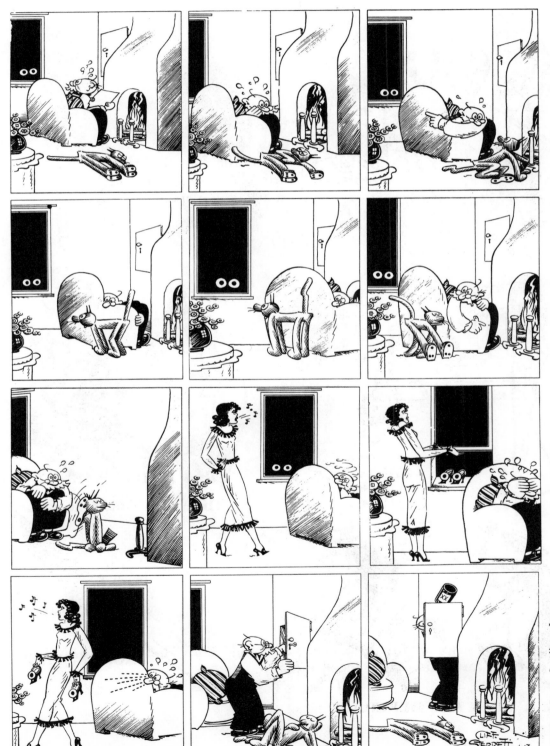

It should be evident to the beginning cartoonist that successful comic strips of the past and present are well drawn and that the writing contained in each is entertaining. An adventure strip holds the reader's interest from episode to episode; a comic strip offers a fresh laugh each time a newspaper rolls off the presses.

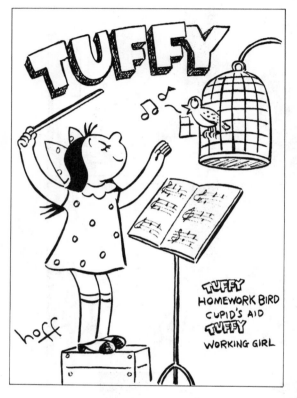

Who is this young lady on the cover of a comic book? She is the star of a comic strip I once did that appeared in 300 daily papers.

These were Tuffy's parents.

This was her older sister, Tessy.

Comic strips are fun to do. I enjoyed doing "Tuffy" but the pressure of other cartooning made me abandon it.

TUFFY

This is the area in which a comic-strip artist works. It can be divided · into two, three, or four boxes, or drawn in just the way it is. Many cartoonists are fond of gathering all their characters together in one panel on Christmas or New Year's to wish their readers a happy holiday.

Try to create a character of your own and write a story about him or her. If writing is not your strong point, consider teaming up with a friend who has more talent in that direction. There are many successful comic-strip writer-artist teams, so don't let a writing weakness discourage you from trying to create a comic strip. And don't be timid about showing your work to your friends, teachers, relatives, and anyone who might be able to offer sensible criticism, thus helping you attain every cartoonist's goal: national syndication.

23
WHERE CAN YOUR CARTOONS BE SEEN NOW?

I F you feel your work is already good enough to be published, mail it to a publishing company. Your local library either has or can obtain directories of newspapers, magazines, and book publishers. Be sure to enclose a return self-addressed, stamped envelope. It would be wonderful if you were accepted the first time, but it's not likely. However, do not be discouraged by a rejection slip. No professional cartoonist ever started his or her career without receiving a quota of "We regret..." slips.

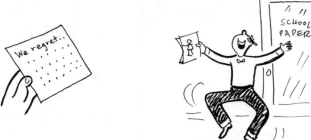

So forget the gloom! Your work can still be seen now. Do you have a school paper? Go see the editor. It's just possible that he or she has an article that would be enhanced by one of your cartoons. Or maybe you can persuade the editor that his publication is in dire need of a few mirth-provoking cartoons.

This is a great way to begin your career. What a thrill it will be to see your first cartoon in print. You'll think that the cartoon is the greatest, even though years later you may wonder why anyone ever agreed to publish it; this is a natural reaction experienced by all artists and is called getting a fresh eye. Most professionals examine their work critically after it appears in print and try to make the next work even better.

If your school does not have a paper, or if the editor decides against using your cartoons, there are other ways to show off your talent.

Is a friend running for class president, or some other office? A funny poster by you might help your buddy get elected.

Consider preparing a number of wall posters urging student participation in club and committee activities. Perhaps the faculty would appreciate displaying a cartoon poster on vandalism or drugs.

Is your school having special problems that need publicizing? Find out whether these are proper subjects for cartoon-wall posters and if the answer is "yes" proceed to create the posters.

Places of worship, fraternal orders, neighborhood associations are constantly in need of volunteer artists. Auto clubs, for example, are always running poster contests on the subject of traffic safety. The grim statistics of highway fatalities can be brought home to every driver and pedestrian much more effectively with a series of deft—even light— cartoons than with a statement of cold facts.

Probably your local police, fire, and health departments also sponsor poster contests. Enter as many of these as you can. Your work will be on display publicly and possibly you'll also win prizes.

Don't forget your local merchants. They might welcome a sign by you advertising their wares, especially if business is slow. These are signs I sold in my own neighborhood while still in elementary school.

I was proud to see them in store windows all over my neighborhood as I would have been if they had appeared in print.

Is the football team trying to raise funds? Maybe your cartoons can spark the drive.

More signs by a beginning cartoonist.

The mark of achievement is to have your work exhibited in a museum or art gallery. Don't be awed by the imposing appearance of these places. Many of them have begun exhibiting the works of past and present cartooning greats. They might also consider showing cartooning greats of the *future*. So don't be timid about showing them your portfolio. Proceed as follows: Ascertain whether an art gallery or museum in your area has plans to sponsor an exhibition of works by cartoonists. If not, it's probably because the idea hasn't occurred to them. Propose such an exhibition. Write, telephone, or drop in to see the curator and discuss it with him or her in person. Don't feel that this

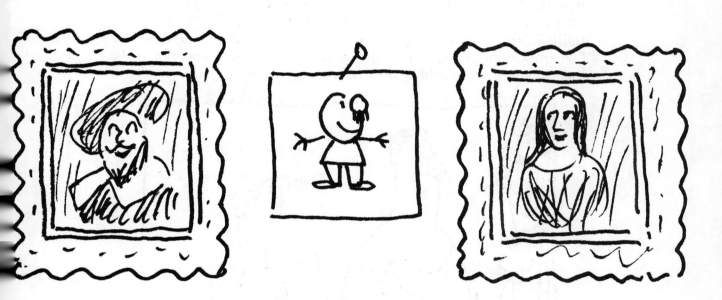

is far-fetched and that your suggestion is unlikely to receive consideration. You'll never know unless you try. The curator may agree that many old masters were little more than cartoonists themselves and so would be glad to make room for a fledgling cartoonist. There could even be exhibitions arranged for beginners, especially if you were to persuade a local company to defray the cost of mounting the exhibit. Modern businessmen are very interested in improving their public image. So get busy on such a project, young cartoonist! And try to get your family involved too.

If you gaze into a bottle of india ink, and try to read it as if it were a crystal ball, the future will undoubtedly look dark. Spend that time, instead, practicing all the things we've discussed in this book. After all, what you can make of yourself in cartooning, or in any other endeavor in this world, is entirely dependent on you and how hard you work at it. The important thing is to enjoy what you're doing and not to be discouraged if the world is slow in hailing you as a genius.

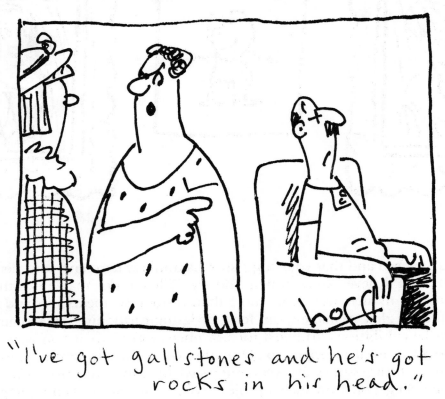

"I've got gallstones and he's got rocks in his head."

This is my first published cartoon, done when I was just beginning my career. Do you think I have improved? You will too!